BEGINNER ART GUIDES

# *Painting*

# LIGHT and SHADE

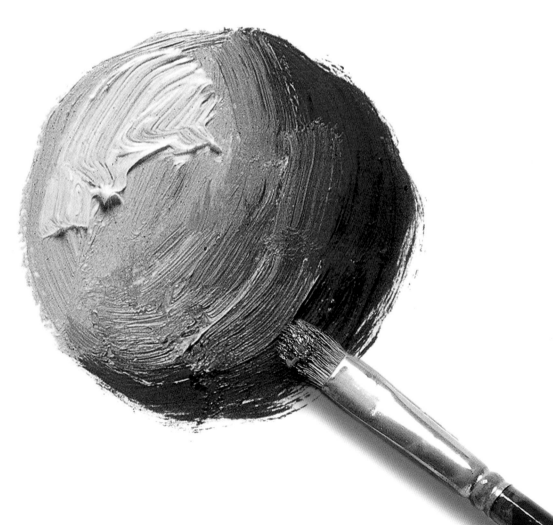

BARRON'S

Original title of the book in Spanish: *Guía Para Principiantes: Nociones de Luz y Sombra*
© 2007 Parramón Ediciones, S.A.–World Rights
Published by Parramón Ediciones, S.A., Barcelona, Spain.

Authors: Parramón's Editorial Team
Text: Gabriel Martín Roig
Exercises: Mercedes Gaspar, Gabriel Martín, Esther Olivé, and Óscar Sanchís
Photography: Nos & Soto

English translation by Michael Brunelle and Beatriz Cortabarría

*All inquiries should be addressed to:*
Barron's Educational Series, Inc.
250 Wireless Boulevard
Hauppauge, NY 11788
**www.barronseduc.com**

ISBN-13: 978-0-7641-6166-7
ISBN-10: 0-7641-6166-0

Library of Congress Control Number: 2007941216

Printed in Spain

9 8 7 6 5 4 3 2 1

# CONTENTS

# Presentation: The Effects of SHADING

Light and shadow are an indivisible binomial; two sides of the same coin. Light is the generating element that introduces the presence of life and vigor; shadow marks the materiality and corporality of objects, stimulating chromatic variety and diversity in a painting. The contrast between light and shadow enters the painting like an active agent helping to define the orientation of objects in space and describing their volume, thus becoming an inherent part of the object.

The effects of light on objects has frequently been used in drawing and painting to define relief and describe texture—the tactile quality of objects. It is an important element to keep in mind. The study of these effects merits the close attention of all artists—beginning or experienced.

Light not only physically defines the visual reality of space, form, and volume, it also introduces a sensitive and emotional level to the painting. Manipulating or moving the light source changes not only the appearance of the illuminated object, but also its dramatic intention and expression. By controlling the color, intensity, quality, and distance from the source of light that falls on the model, it is possible to create many moods. Joyful scenes are created with effusive colors; while strong direct light creates very strong contrasts, resulting in dramatic environments. Mysterious phantasmagoric atmospheres are achieved by illuminating still lifes with a very tenuous light (as if the shapes of the objects are slowly emerging from the heavy darkness) or removing any shadow to reveal the mystery that hides it in darkness, bathing the subject in a diffused light.

Because of the important role of illumination in the construction of the pictorial image, and the shading that results from that light, this technique has become widely used by most artists, whether valorists or colorists, by all who avoid a strictly linear treatment, and those who base the construction of their paintings on tonal contrast or chromatic color ranges.

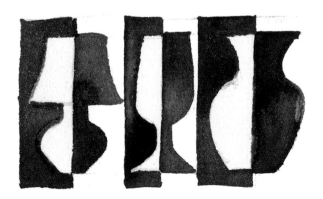

# *General Principles for Depicting* LIGHT *and* SHADE

A work of art constructed solely of lines or linear brushstrokes can't sufficiently explain the volume and distance of each plane. To do so requires the use of light and its contrast with the shadows that act as defining and clarifying elements. The appearance of a shadow expands the limits of a drawing and takes it to the realm of painting. When shadows appear as a response to light, the artist knows that he or she is entering a world beyond mere physical appearance. The subject becomes more dynamic, varied, and entertaining. The use of contrast—the confrontation between light and dark—becomes the goal, causing the highlights, the incidental, and the reflected light to become more interesting. The painter using light effects is very conscious of the power of contrast. We invite you to discover the technique of creating light and shade along with introducing diverse approaches that offer a great variety of interpretive solutions.

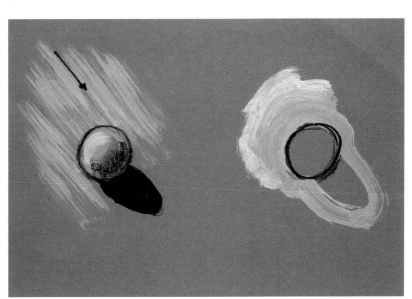

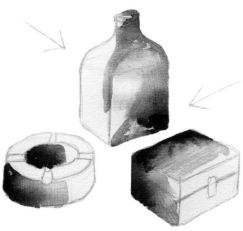

# The Effect of LIGHT

*Shadows can confuse us or create impossible scenes like the one shown here, in which three objects appear to cast incorrect shadows from three different light sources.*

Light is a phenomenon that is related to the immaterial, and as such, ignores the laws of gravity. It is an element full of conceptual, symbolic, and vital concepts. Light adds certain magic, and it is related to everything that has a spiritual aura. Because of this, it is not difficult to understand that the attraction of light to the artist is due to more than merely its practical function as an element that defines space and volume.

## Light Reveals the Object

Light, depending on its intensity, color, and origin, reveals life and determines the way we perceive the world. Without it nothing would be visible to our eyes. In the physical aspect, light allows us to discover the form and size of objects. In some cases, we are talking about light that creates a very sensual atmosphere; in others, about a full light that creates strong contrasts that emphasize the form of the objects; and in still others it is a blinding light in silhouette that perturbs the outlines of things and evokes a supernatural world.

## The Descriptive and Compositional Function of Light and Shadow

Light plays a determining role in the perception of a painting. The concert of light and dark present an immediate view of the disposition of the elements, of the content of the work. If the tonal palette is strong, it will invite a closer and longer examination. Besides that which is purely descriptive, the distribution of light and shade is organized based on a compositional intention, ordering the parts, and creating visual journeys.

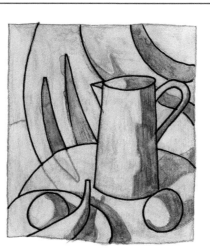
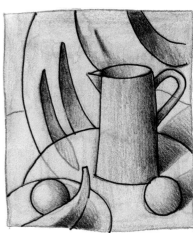

*In a monochromatic representation the absence of shading creates a flat image, lacking rhythm and attractiveness for the viewer.*

*Flat surface shadows and projected shadows create defining shapes, activate rhythm, and add interesting dynamic effects in the painting.*

*If the shading includes gradations (light transitions in the tones), the three-dimensionality of the objects is increased.*

*Shadows help organize the content of a work of art. In this first image created with lines, everything seems located on the same plane.*

*Adding shadows gives new meaning to the drawing. Each plane is much easier to distinguish.*

## Light Orients Us

The distribution of areas of light and shade provide much information about the orientation of the objects. A strongly illuminated area indicates that a given surface is turned toward the light source; while darkness implies that it is turned to the opposite side. The distribution of light helps define the location of the objects in space.

## Must Shading Reflect Reality?

Not necessarily. In general, the shading in drawings should be rational and perceptive. It should appear real, representing atmosphere and the illumination of the objects from a natural or artificial light source. Failing to follow this criteria would create an incongruent and disconcerting composition. Nevertheless, in some cases shading can be modified in an unreal manner. For instance, varying the intensity of the shading in some parts of the painting will accentuate a form with a false contrast or strengthen the dynamic effects of the picture by deforming or stylizing the projected shadows.

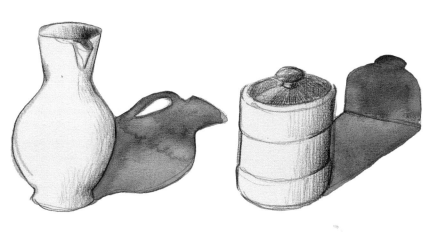

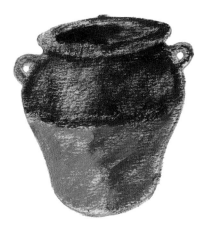

*Shadows explain the object's hidden realities. Here, the shadow tells us that the pitcher's handle is hidden from our point of view.*

*Shadows provide information about the space. Here, the projected shadow reveals that the space is limited and that a vertical plane exists a few inches behind the model.*

*Shadows also explain the texture of the object. Shading the object with a rough treatment indicates the tactile quality of the unglazed pottery.*

SHADING OFFERS INFORMATION

9

# The SHADOW
## Creates Volume

As a consequence of light and shadow, light causes certain phenomena on objects. Edges are defined by their contrast with the background; a visual re-creation of the third dimension is created by modeling the volume, and finally, texture and internal relief (depth, planes, hollow) are defined.

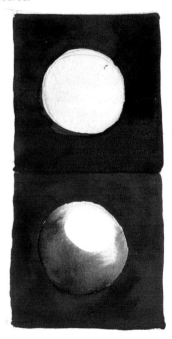

### The Fourth Dimension

In traditional drawing manuals shading is usually done after an analytic process in which three perceptive dimensions have been resolved: perception of the edges, perception of the spaces, and the relationships between the different elements (composition and proportion). Once an artist has mastered these three perceptives he or she is ready to integrate them with a fourth dimension, the representation of the shadows. The effects of light and shadow give a visual representation of what the object is like: its tactile quality, and its volume.

**DIRECTION OF THE BRUSHSTROKE**

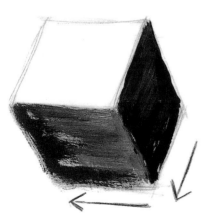

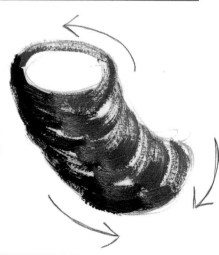

*Each surface that is shaded requires a specific direction for the brushstroke. A flat surface requires straight brushstrokes.*

*A curved surface needs wavy brushstrokes. The brush is moved as if it were actually touching the object.*

*To create a cylindrical form the brushstrokes make rings, following the direction the hand would take if caressing the object.*

*The shading on the objects themselves is fundamental to understanding the volume of a building, distinguishing doors, windows, and the near and far planes.*

**Tip**

*To see more contrasted shading on a model try squinting your eyes or viewing the model through colored glass or acetate. This reduces the amount of color seen, making the tones stand out.*

*The effect of gradated shading is basic to constructing more complex forms and elements in a convincing manner.*

*When an object has no shading, it looks flat, lacking any information that reveals its texture and tactile qualities. This doubt disappears when shading is employed.*

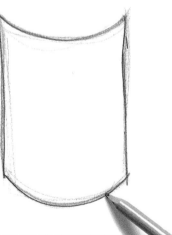

## Volume with Gradation

The fusion of one color or tone with another so that no edge can be perceived between them is called gradation. Gradations define the volumetric characteristics of the form through the correct application of light and shading on the object. This progressive movement from light to dark is done by blending; mixing the colors in a very gradual manner.

## Curved and Spherical Surfaces

On curved, cylindrical, and spherical surfaces the tone of the color changes with the effect of the light, creating a range of tones that move from the lightest to the darkest. Gradation is used to communicate the roundness of solid bodies, making the objects appear three-dimensional. A progressive reduction of the incidence of light on the curved surface is all that is needed to achieve this.

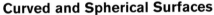

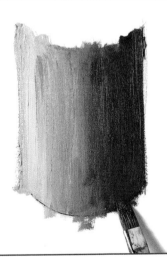

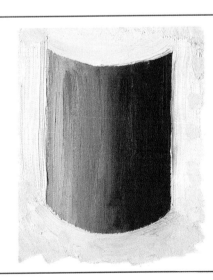

*Gradated shading can change a simple flat shape such as this one into an object with volume.*

*The valuation of tones must be gradual, with no strong contrasts. This is done by mixing the still-fresh paint.*

*The transitions of color are made with the tip of the brush. The passage from one tone to another should be gradual and without brusque changes. The volume effects are evident.*

**GRADATING GIVES VOLUME**

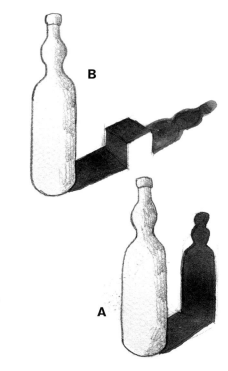

**B**

**A**

# *The* PROJECTED SHADOW
## *Creates Space*

While the shadows (or shading) on an object in a still life help to reveal form, in a landscape or interior painting projected shadows are the more important element. Projected shadows are those that an object casts on the floor, wall, or other nearby surface.

### An Extension of the Object
Projected shadows have the same physical aspects as those on the object, but they are perceived very differently. They are not part of the object, but rather a projection of it; they create a sense of space by emitting darkness in areas of light. These shadows project from the object across a flat surface or another object. Projected shadows emphasize the spatial sense of the subject, directing attention to the space that surrounds the model and anchoring the object to the surface it rests on. It is very important to paint them correctly.

*Projected shadows produce a theatrical, phantasmagoric effect, often distorting the model.*

*This abstract composition of lines has a flat appearance.*

*With the addition of tonal shading in each section, the differences between the superimposed planes can be sensed, but are still not explicit enough.*

*Adding projected shadows helps the grouping acquire volume. A grouping of various planes arranged one over the other can now be distinguished.*

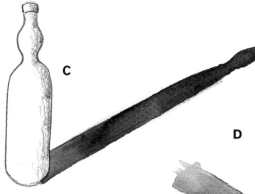

**C**

**D**

The shadow projected by an object is a good indicator of the surrounding space, the position of the source of light, and its intensity. For example, in the first drawing (**A**) it is clear that there is a vertical plane behind the bottle; in the next (**B**) the shadow crosses a square object. In the drawing above (**C**) it shows that the light source is low, and in the last (**D**), we see that there are four sources of light.

**Tip**

*Don't draw outlines around the objects being drawn before shading them. Once the shading is applied, the outlines will create themselves.*

## Perspective in the Shadows

Projected shadows are the projection of the silhouette of an object on a plane. All projected shadows are subject to the laws of perspective, whether the light is natural or artificial. To create a shadow and calculate its extension, we only have to envision straight lines that originate at the light source, pass across the outline of the object, and project its silhouette on the ground plane.

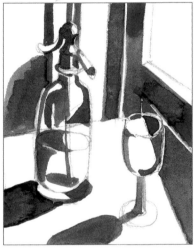

*These flat shadows are made with dark, even areas with no values or gradation. The shadows are solid and the contrast with the light is extreme.*

## Flat Shadows

Projected shadows usually reproduce the silhouette of an object, with no variations or values. A good way to understand them is to draw flat shadows, that is, blocks of a dark unmixed color that make it easy to clearly see the particular form and distribution of the shadows that are projected in the model. Dark areas are simply drawn to correspond to the areas of shadow in the model, looking only at the shape and their strong contrast.

*Here are three different interpretations of the outlines of projected shadows. In the first the shadow is harsh, and the edge of the shadow is the same: clear, contrasting, and harsh.*

*When the light source has a shade or is far away, the edge of the shadow is not as harsh. It has a blended edge and light gradation.*

*When the object that projects the shadow is complicated and without a clear edge, the projected shadow is broken and has areas of light within it.*

**THE OUTLINES OF SHADOWS**

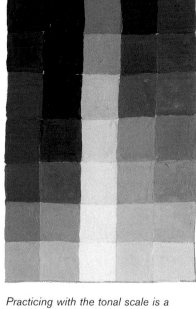

# VALUE:
## VARIATIONS *in* SHADING

*Practicing with the tonal scale is a good way to learn to create different intensities of the same color.*

Fix your gaze on any dark corner hidden from the light and you'll discover that the shadows are not the same darkness and do not have the same tone. Some areas are more intense than others. Learning to distinguish these differences, by means of careful observation of the model, is one of the artist's most important tasks.

### The Intensity of the Shadows

Shadows are rarely homogenous; they show numerous shades. Whether or not some shadows are darker than others depends on the difficulty that the light has in reaching each part of the shadow. The more covered, enclosed, or distanced the light from a surface, the darker the shadows. The traditional way of painting shadows is to greatly darken the local color of the object. There's no need to limit oneself to using black in the mixtures, as shadows can also be done with blues, violets, and browns.

### Drawings with Tonal Scales

Practicing painting the tonal scale—the progressive gradation of color from light to dark—will help you to develop your ability to perceive subtle changes in tone. This much-used technique allows for beginners to become sensitized and gain control in creating a wide range of values.

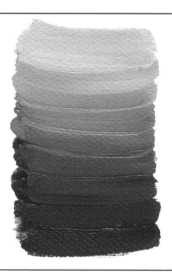

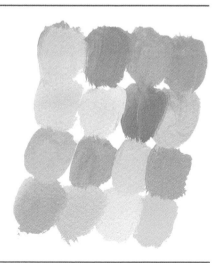

*Creating different variations of a tone is easy. There are different ways to do this; the first is to lighten a color by progressively mixing it with white.*

*Another common technique is based on blending one color toward another. This means mixing the two colors in unequal amounts to create a tonal scale.*

*For rich tonalities, light colors like yellow must be mixed with adjacent colors from the color wheel.*

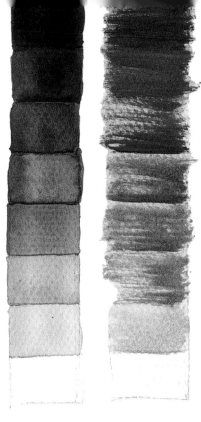

*When working with watercolors, it is not necessary to add white. The lightest tones are created by diluting the color with water.*

*To shade correctly, make small notations of color based on a single color mixed with white.*

### Tip

*When working with watercolors or acrylics each tonal increment is established by adding a layer, and then repeating this until the desired dark tone is reached.*

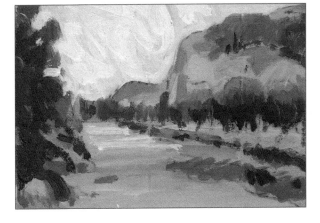

## Use Caution with Blacks and Whites

If preliminary sketches are made using only undefined brushstrokes of light and shadow with limited detail, the valuation progresses little by little and can easily be adjusted and corrected.

Don't make the mistake of deciding that the lightest area will be white and the darkest black. When there is little light in a scene the lightest value is usually a medium gray; pure white is uncommon. The same holds true for pure black; it rarely appears in a scene.

## Compare and Limit the Tones

Shading correctly means establishing large groups of tones before working with the smaller and more specific ones that are part of them. The technique for creating values of light consists of seeing the scene as a succession of areas of light that are not seen individually, but that interact and balance each other. The tones and colors in a painting are comparable to musical notes. Too many different tones create a visual dissonance, while a controlled tonal range, adjusted to a light or dark scale, creates harmony and emphasizes the emotional level.

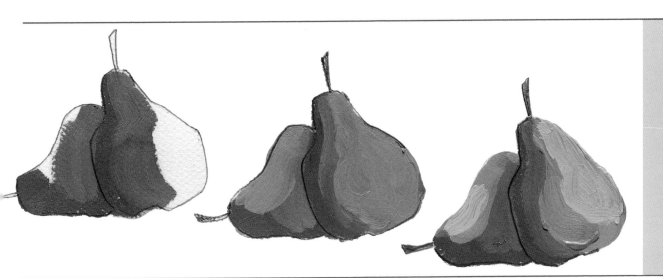

*Shading correctly means learning to establish large areas of tones. Let's look at a practical example: two pears that are colored with two shades of green.*

*A new tone is applied; this one a lighter green than the previous ones. Each new addition of tone is lighter than the one before.*

*To conclude, the illuminated area is painted with a yellow green. The use of tones with slightly different values tends to create calm, sober effects.*

**CONSTRUCTING WITH TONAL GRADATIONS**

*For gradations it is necessary to lighten or darken a color progressively, without sudden changes in tone.*

# LANDSCAPES: *The Importance of* GRADATIONS

Light and color are very closely linked in the landscape. The most eye-catching and surprising aspects of a landscape are always related to the light and color of the atmosphere. Morning fog, the light of dusk, the radiant color of flowers, mountain peaks gilded by the late afternoon sun, stormy skies, sunlight between the leaves of trees, these are all moments with a special feeling that always relate to the light in one way or another.

## A Changing Natural Light

Painting a landscape means painting natural light subject to constant changes determined by the position of the sun and the weather. One of the main factors that influence this is the appreciation of the density of the air; it acts as a filter with winter fog and the heavy, hot atmosphere of summer.

## Gradients of Light

Gradated shading is the best way to describe the effect of fading coloration that is caused by light on the landscape as it recedes into the distance. To create a gradated color, begin with an intense tone, reducing its value until arriving at the lightest colors. If the gradation depicts the general coloration of the landscape, the changes in light help differentiate the planes, creating a sense of depth.

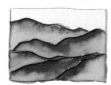

*Gradations are fundamental to creating a sense of distance in the landscape. Here we show two representations: the immensity of the sea, and a group of hills.*

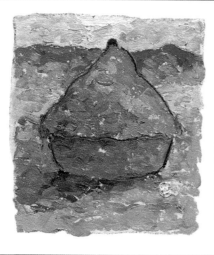

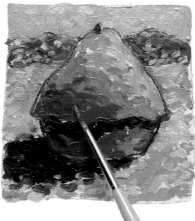

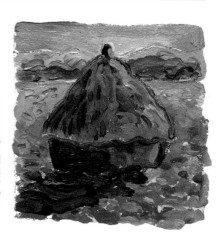

*In a small homage to Monet, we have attempted to paint a haystack at different times of the day. This version in blue corresponds to dawn.*

*When the sun is high, the ochres, yellows, and oranges are more pronounced.*

*At dusk, with the sun near the horizon, the light becomes more red and orange and the shadows tend to have violet tones.*

When overlapping planes are encountered, such as a group of trees with tones of little contrast, they are depicted flat.

To make the overlaps easier to see, gradations that strengthen the light and dark areas of each tree are developed.

## Light in Overlapping Planes

In landscape with a lot of vegetation, shadows can be disconcerting as they blur outlines and create confusion between different areas. The opposite happens when differences in the light are used to separate the overlapping objects from each other (in this case different superimposed areas of vegetation). Modifying or falsifying the real conditions of light in certain areas creates a sense of depth, while the contrasting light emphasizes the overlap.

### Tip

In landscapes it is considered appropriate for drawings and paintings to have an inclination between 30° and 60°, depending on the position of the sun. However, it is common to see a 45° shadow used to graphically represent an object on a sheet of paper.

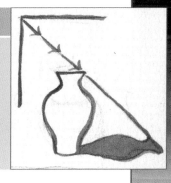

## Intense and Blinding Sunlight

Natural radiant light invigorates the colors of the landscape, but it is very difficult to paint a scene bathed in intense light without the use of shadows, as they are the true indicators of the intensity of the light. The darker and more contrasting the shadows, the more intense the daylight. When the sun rises or sets, the light is low and can create a frontal or backlit illumination, depending on whether the viewer is facing toward or away from the sun. Backlighting creates a blinding effect and darkens the objects before us.

During the first hours of the day the light is bluish and without much contrast. The entire landscape is wrapped in a blurry, foggy atmosphere.

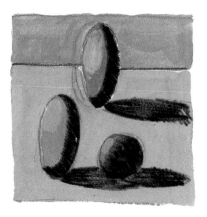

**BRIGHT LIGHT**

When bright sun floods the landscape we tend to think that it is enough to paint with bright, saturated colors. This is not the case.

Some artists apply varied tones to the objects in the landscape, shown here in a simplified form. This too will not suffice.

To convincingly convey the sense of a hot summer sun, very dark shadows must be added. Without them there is no sun.

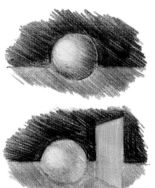

*Chiaroscuro is very common in still life paintings. It emphasizes the contrast between light and shadow through modeling and gradations and without sudden changes.*

# CHIAROSCURO:
## *The* POWER *of* DARKNESS

The technique of chiaroscuro consists of modulating the light on a dark background, creating contrasts that suggest relief and depth. In other words, it is a careful distribution of light and shadow in the painting. When shadows invade one part of the model in a generous and contrasting manner, the drama is increased and one is brought closer to the impassioned message of the work.

*When the background of a chiaroscuro is black it contaminates the shaded parts of the objects. But when a luminous object acts as a screen it throws some light on nearby shadows.*

### Chiaroscuro

The chiaroscuro effect breaks with monotonous light, offering an image where light and shadow struggle violently to make space for themselves. Intense contrasts of light and penumbra increase the drama of the scene.

### Reflected Light

In chiaroscuro representations, the background is usually black or dark, so that the shadow completely covers the side of the object that is facing away from the light, causing it to blend into the background. However, when one of the objects in the composition or a part of the background is white or light yellow, it reflects the rays of light, acting as a screen that throws reflected light on the nearby shadows. These shadows become a new light source of lesser intensity. After the shadow has reached its maximum intensity, it becomes less dark, and light returns to the scene.

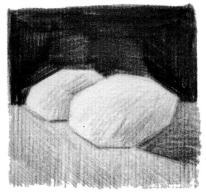

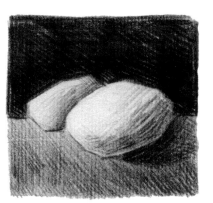

*One of the greatest mistakes beginners make when working a chiaroscuro is to darken the shadows too much. This largely mitigates the effects of the light.*

*The opposite effect is to illuminate the scene too much. Don't be afraid to use shade; without it the objects will show little volume and contrast.*

*It is necessary to find a harmonious balance of light and darkness. The dark background helps the profile of each element stand out.*

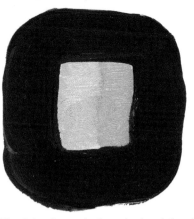

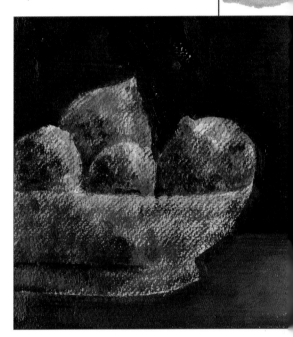

*The light of a particular color is relative. Here we see how the same colors surrounded by a black background seem lighter than when they are surrounded by light gray.*

*Tenebrism is about the nearly complete absence of light. The scenes seem to be lit by a very weak light that empowers the shadows.*

## Relative Luminosity

The amount of light on an isolated object depends not only on its capacity for absorbing or reflecting the light, but also on the distribution of the light values in the whole scene and, more specifically, on the intensity of the tones that surround it. For example, a gray or ochre object may seem light and bright when surrounded by shadow, not because it radiates much light, but because of the contrast of the black background that emphasizes the lightness of the color.

## Tenebrism

In painting, this technique suggests forms in a particular environment with little light and surrounded by darkness; it promotes the near absence of light. The darkness that takes over the painting is counteracted only by a small light source, generally a lamp or candle, which is present within the painted scene. This obliges the artist to illuminate the scene from the shadow, and do it very carefully. The darkness should not be used negatively, for example by removing the intrinsic light of the object, but more as an effect of hiding luminous objects.

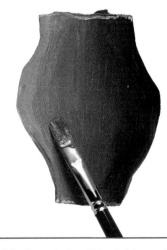

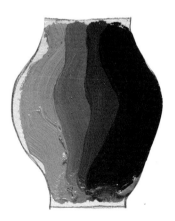

*The first step in mixing colors on a chiaroscuro surface is to apply different tonalities with a series of brushstrokes.*

*Colors are darkened progressively in a clear tonal gradation of browns. The paint is thick and dense.*

*While the paint is still fresh it is gently mixed with a soft-hair brush. This converts the tonal scale to a gradation.*

**MIXING IN CHIAROSCURO**

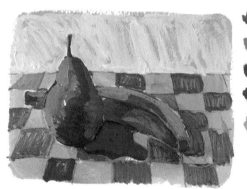

# Brightly-COLORED SHADOWS

We tend to think that the total absence of light results in brown and gray colors, or the darkest black, but reducing light does not necessarily mean that the colors in a painting must become darker. Contrast between the illuminated areas and shadows can be achieved using color contrast.

*Many watercolorists use blue washes to lay out the shading in a drawing.*

*A quick sketch shows a range of reds for the illuminated areas that contrast with the blue shadows.*

### Color Displaces Darkness

We often assume that projected shadows are the same color as the space on which they are projected, but of a darker tone. This valorist concept is traditional and academic, and was transformed with the arrival of Impressionism, when some artists chose to replace dark tones with lighter, more lively, and vibrant ones to represent shadows.

*The contrast between complementary colors is very strong and active when the edges are clearly outlined.*

*When one of the colors overlaps the other in the form of a translucent wash there is a certain mixing of the colors. This creates less distinct outlines.*

*Blending lightens the contrast between the green and red. If the saturation of the green is reduced the colors will mix better, although they move away from the complementary contrast.*

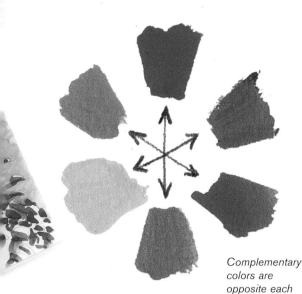

**Tip**

A saturated and intense color effect can be created by painting over a brightly-colored background. The effect will be more dynamic if the background color is not completely covered.

A          B          C

## Blue Shadows

With the Impressionists, color replaced the shading in chiaroscuro, and the areas of light and of color were represented with an illuminated palette. In the practice of coloring shadows, the Impressionists agreed that when the light is not very bright it gets cool, consequently becoming blue or violet. The same thing happens to the colors in the landscape at dawn and at dusk. For this reason, many artists first paint the shadows of the model with flat washes of blue. This manner of starting the painting facilitates the layout and a correct distribution of the light.

*Complementary colors are opposite each other on the color wheel. Because they are so far apart they produce a maximum contrast of color.*

*There are three pairs of basic complementary colors. In the first (**A**), orange represents light, and the blue, shadow. In the second (**B**), the light is painted with red, reserving the green for the shadow. In the last (**C**), the yellow represents the light, and violet, the shadow. An analysis of these three examples shows that the warm colors always represent the light.*

## Contrasting Complementary Colors

The relationship between complementary colors finds the greatest possible contrast between two colors opposite each other on the color wheel, causing compression and tension. Creating lights with yellow tones and shadows with violet produces the greatest shock between the heat of the sun and the coolness of the shade.

## Contrasting Ranges

The contrasts of light can also be based on strong contrasts between different colors. Under a strong light, the illuminated areas are harsh and can be resolved with a range of warm colors: yellow, orange, and red. The shadows are related with a range of cool or neutral colors.

 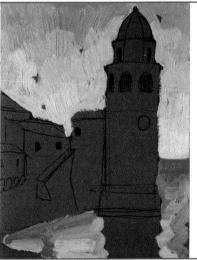 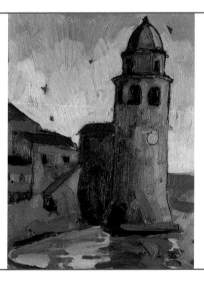

*When painting with contrasting complementary colors (in this case yellow and violet) we must resort to adjacent colors from the color wheel to increase our palette.*

*Five or six variations of yellow and orange tones can more attractively represent the illuminated areas of the model.*

*The shaded areas are resolved with violet, the complement of yellow. Working with adjacent colors allows the blending of violet toward carmine and blue.*

**ADJACENT COMPLEMENTARY COLORS**

# SKETCHES *with* SHADING

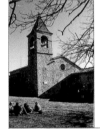

This exercise creates a shaded sketch over a line drawing. Using a stick of water-soluble wax that will later be dampened with a brush, lay out the space and distribute the main light contrasts. The shadows can be indicated with just two or three gray tones. These are preliminary sketches for paintings; they are used to ensure that the distribution of light and shadow is understood correctly. These examples will help you see how to work.

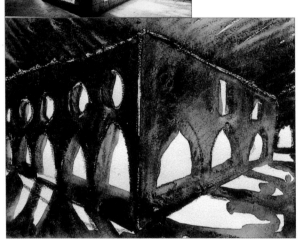

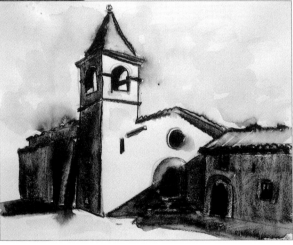

*In the first example, the limits between the lights and the shadows are very clear. The interiors of the wings of the cloister are submerged in darkness, while the interiors of the arches are white. On the ground new areas of white explain the light that penetrates the architecture and is projected on the floor.*

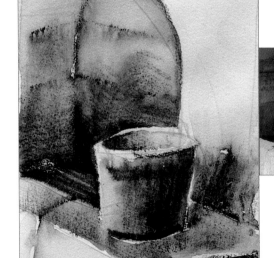

*When presented with the challenge of representing architecture, the use of shadows is fundamental to expressing the volume and the form of the building. Conceive the grouping as if it is made up with geometric forms and shade the sides that are not exposed to direct light. The darkest blacks should be left for the openings in the facades and the rest resolved with a scale of grays.*

*This sketch uses light gradations to help indicate the volume of the bucket and the tonal gradations of the surrounding space. When working with gradations, the gray tones should be lighter. Remember to always shade lightly, leaving white areas where the light falls. If it is necessary to accentuate the black more in some areas it can be done later.*

# PROJECTED *Shadows:* SHADE *and* LIGHT

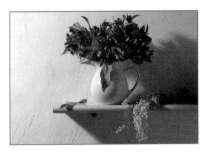

There are two basic ways of constructing projected shadows, each depending on the color of the support and on the way that the model is lit. One or the other will be used according to the situation. This example uses a model that, because of its particular characteristics, can be resolved by either method without apparent difficulty.

SHEET

PRACTICE

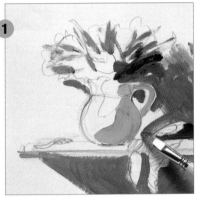

*1.* The most common manner of working is shading with values—using brown or black tones to darken the space corresponding to the shadow projected by the object. The three areas left white correspond to the illuminated areas.

*2.* The evolution of the process is simple; later lighter colors will be used in the more illuminated zones. In a matter of a few minutes a convincing shaded sketch is completed.

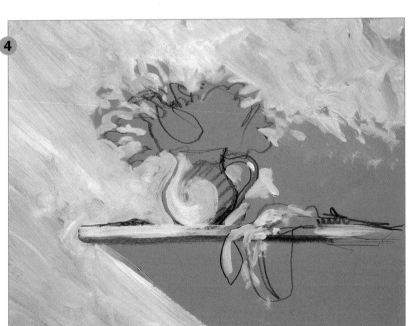

*3.* The second way of constructing a projected shadow is the one preferred by professionals. Work is done on a colored background, covering the illuminated areas with light paint.

*4.* When painting the light, the areas that are not illuminated show the gray color of the support. It is like painting the shadows by omission; lightening part of the painting causes the shading on the pitcher—and its projected shadow—to appear almost without trying.

## *Under the Influence of* ARTIFICIAL LIGHT

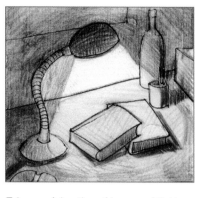

*Take careful notice of beams of light and learn to recognize the edges between the areas illuminated by the lamp and the surrounding shadows.*

Light from lamps or a city's streetlamps create a theatrical feeling that is not at all natural. Whether it is an incandescent, halogen, or fluorescent lamp, artificial light can considerably alter the color of objects.

### The Color of Light

Light changes color every hour. At dawn it is bluish; in the late hours of the day it is yellowish or orange. At night, the light in the streets can be of a yellow, green, or orange color. The color of the light washes over objects, altering them and creating a different look. The color of an object is not unchanging, rather, the spectral composition of the light reflected from the object always depends on the existing illumination.

*Small monochromatic notes like these help explain where the light comes from and how it illuminates the scene.*

### Beams of Light

To paint beams or rays of light, we first must know that they travel in straight and radial lines. Therefore, the light source should be painted lighter, and the light should be progressively gradated as it moves away. The final result is a light source with a circular halo that is gradated to resemble an aura. The light beam can also be painted with lighter and more intense colors near the source and diluted as it moves away, creating a canyon of light.

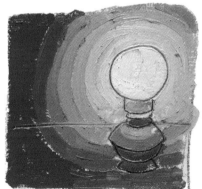

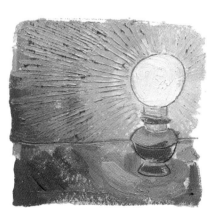

*When painting a light source, the lamp should be painted with white or a very light yellow. A halo is created with yellowish brushstrokes.*

*The propagation of light is represented with circular brushstrokes that show a clear tonal scale of orange colors.*

*The effect of radiated light can be shown by making sgraffito with the handle of the brush, drawing radial lines that go in all directions from the lamp.*

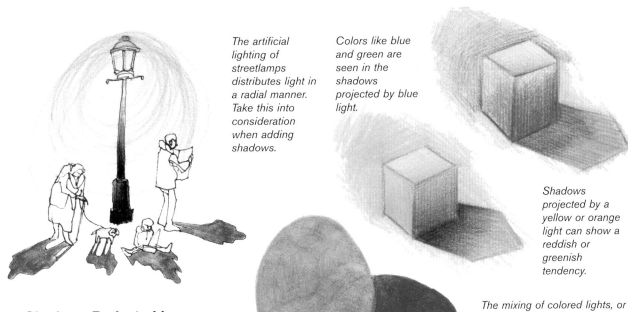

*The artificial lighting of streetlamps distributes light in a radial manner. Take this into consideration when adding shadows.*

*Colors like blue and green are seen in the shadows projected by blue light.*

*Shadows projected by a yellow or orange light can show a reddish or greenish tendency.*

## Shadows Projected by Artificial Light

Shadows created by an artificial light are usually more distorted than shadows created by sunlight and project in a straight line from a vanishing point located just below the light. Viewing a streetlamp you'll notice that artificial light projects in a radial manner, which means that the shadows of objects are also projected this way. Their direction will always be opposite that of the light source.

*The mixing of colored lights, or additive color mixing, is ruled by a different principle than that of mixing colors on the palette. The basic colors are red, green, and indigo. When they are mixed they make cyan, magenta, and yellow.*

## The Chromatics of Shadows Cast by Colored Lights

A bluish light is composed of light waves of indigo and green; yellow light is made by red and green waves, which also contain some blue. This means that the yellow lights of big cities do not project shadows with red and green tendencies, not of bluish tones. Avoid contrasting complementary colors when painting nocturnal urban scenes and pay more attention to the additive mixture of colors or mixing of light.

*Here are three aspects to consider in nocturnal paintings. Facades show gradation, the lower part being the lightest, with small reflections on the balconies.*

*Take notice of the bollards in the street. Since they are illuminated by different light sources, they cast several shadows at once. In some cases, they are of different colors.*

*Trees are illuminated from below by the streetlamps, so highlights will be visible on the lowest branches, while the highest branches will be darkest.*

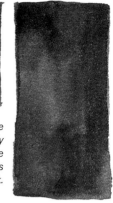

## *The* RELIEF EFFECT

# HIGHLIGHTS:
## *Relief Effect*

*Black spaces on a white background are psychologically interpreted as empty space. The white is always perceived as being closer than the black.*

Highlights are the reflections of light that are seen on the surface of smooth objects. Like shadows, they can help define and create the volume and contrast in a painting.

### Near and Far
When white and black are applied on the same surface, the white will always seem much closer and the black farther away. When artists want something to appear hollow, such as the mouth of a pitcher, they paint it black or brown. But when they want something to stand out, they paint the nearby areas with dark colors so they appear to recede, and create highlights of white or other light colors on the element that should come forward.

### Three-dimensionality
A reflection is an added tone that is much more luminous than the general dynamic of the rest of the work of art. It emphasizes the smooth and reflective surface of the material, the brusque changes of light in an area, or forces the contrast to better explain some facet of the model.

*Reflections are the areas of the model that are most strongly illuminated. The areas of light should stand out more than the areas of shadow.*

*The blue background of this painting allows the artist to create the facades of a group of houses using solely highlights. Only the illuminated facades are painted white.*

*Shadows are modified by covering the blue with new colors to model the contrast between light and shadow.*

*Gradations are used to modify the light on a facade. This helps create a center of interest.*

26

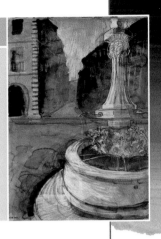

*Highlights are the reflections of the light source on the polished surfaces of the model. They are very small and are made with near-white tones.*

**Tip**

*Keep several pages of your notebook painted with medium-brown and dark backgrounds so you can easily combine dark shadows with highlights made with chalk or gouache.*

## The Color of Reflections

Many beginning artists make the mistake of thinking that highlights are always white. Each object, according to its material color, acts as a reflective screen; this means that part of the color of an object will be more or less present in the highlight. An orange, for example, will have a reflection of light yellow; a tomato will have pink. Stainless steel and silver can use completely white reflections.

## Highlights and Reflections

Reflections are areas of increased contrast of light on some parts of an object. They are the result of the reflection of the light source on objects that have smooth or polished surfaces. Often small points or highlights appear that are almost as bright as the light source itself.

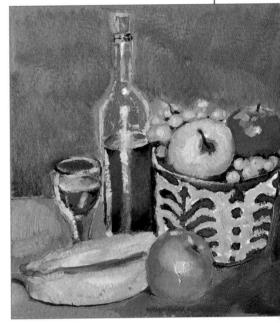

*Reflections are not always white. They appear so on glass, but they are pink on the apple, and white tinted with ochre or orange on the orange.*

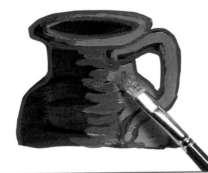

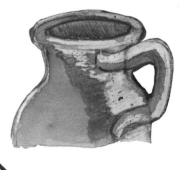

REFLECTIONS ON A COLORED GROUND

*When working with reflections it is important to apply a mid-tone to the support before starting. White paint can then be used to indicate the areas of light.*

*If the background is darker, so must be the colors of the reflections. White cannot be used; a light sienna would be more appropriate.*

*When painting watercolor washes on white, the reflections are indicated by not painting small areas, or by previously making reserves by coloring the areas with white wax.*

# REFLECTIONS *of* LIGHT *on* WATER

The impact of light is increased when, in addition to shadows, a surface of water is included in the theme. Water, like most liquids, acts as a large collector of light, where both with nearby objects and the colors of the surrounding space are reflected. This is a theme loved by many artists because of its great artistic potential.

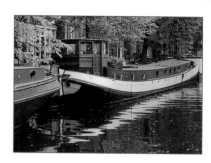

**1.** When drawing a reflection, the artist first becomes aware that it is projected vertically on the water, with a strong line at first, then wavy and broken up lines as it moves away from the object. This curious principle creates a very decorative design full of arabesques and confusing shapes that invite the artist to make a freer interpretation than usual.

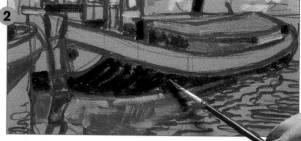

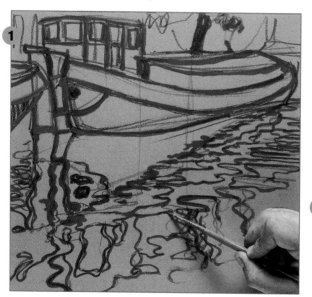

**2.** The boat is painted with its characteristic colors, providing a guide for creating the reflections. The style of painting is quite simple and stylized—an interpretation verging on Fauvism. In the reflections, the real colors are altered and the placement is similar to that of the reflected object, only inverted.

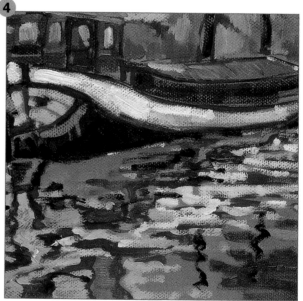

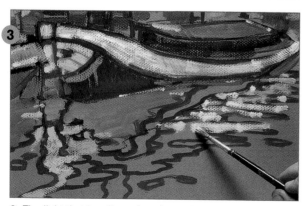

**3.** The light that is reflected on the surface of the water should be painted with horizontal brushstrokes, arranged in capricious, zigzag shapes. The lines painted in red are preserved in some areas to increase the agitation and dynamism of the surface.

**4.** The greater the movement of the water, the less definition there is in the reflected image, to the point of reducing the reflected object and the environmental light to multiple highlights. By observing the scene, the viewer can guess the colors and the shape of the boat and the nearby vegetation.

# LIGHT COLORS *on* BLACK

Painting on a completely black background is uncommon among professional artists; but for beginners, doing so serves as a good exercise for paying closer attention to the process of illumination. Paint just the light and try to forget about the normal techniques of shading (at least temporarily) to condition your working process.

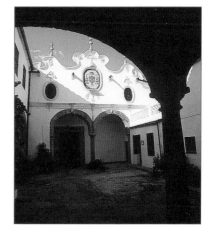

*1.* On a completely black support using a white pencil, an interior patio of a convent, deep in shadow, is drawn. Then, the partially illuminated areas are painted in medium tones with paint diluted in turpentine.

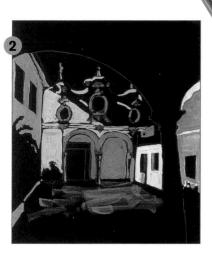

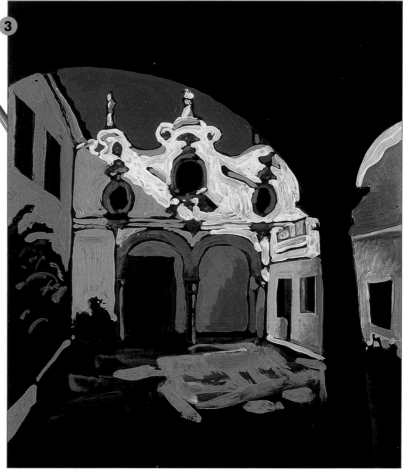

*2.* Two tones of light violet are used to construct the facade of the building. Each area is painted carefully, as if it were a puzzle with each piece fitting into the other. By reserving small spaces that form a black line, the background color becomes part of the lines that define this typical architecture.

*3.* The sky is finished with an intense blue, and finally, the parts of the facade that receive direct sunlight are painted white. The arch and the column in the foreground are silhouettes that seem to be submerged in complete darkness.

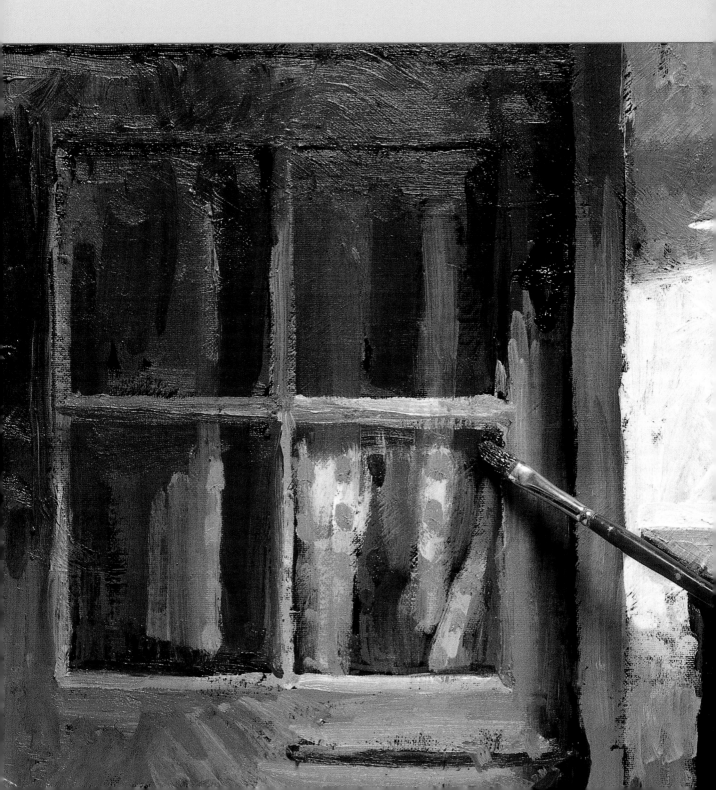

# PRACTICAL EXERCISES

The effects light and shadow produce in a scene can be perceived as poetic, soft, hard, contrasting, rotund, or expressive, depending on the media chosen for painting. Each medium has its own personality and requires its own techniques and solutions according to the occasion. The following pages explore the options and techniques that are within our reach to depict the effects of light in the painting from a practical view. You will experiment with the possibilities of the tonal scales, contrasting colors, and reflections, and see how the choice of one or the other working technique determines the final effect of the work of art.

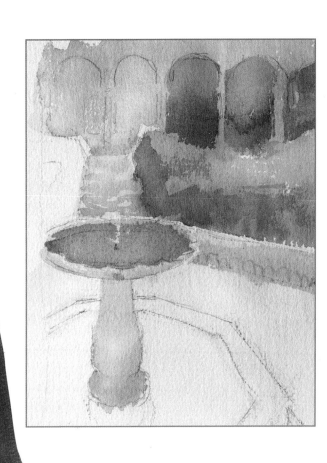

# *Basic* SHADING

## BRUSHSTROKE: *The* *Basic* TECHNIQUE *of* SHADING

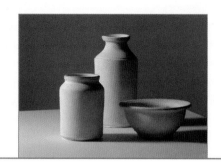

The first exercise is very simple, constructing a model with just two colors: black and white. This allows you to set aside the difficulties of color and concentrate solely on the amount of light in each area. It is based on a simple model composed of white objects, which abound in art schools. Place the objects so that they cast strong light and shadow. The use of artificial light makes this exercise easier because it is not as subtle as natural light. Gabriel Martín created this exercise with oil paint.

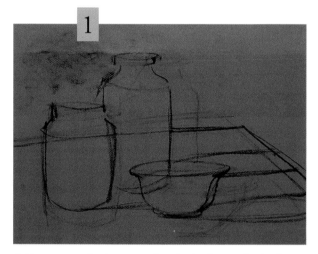

*A blue support is chosen so that the background color is approximately equal to the middle tone of the painting. The drawing, done with charcoal, distributes the different elements in the painting. It is not necessary to make the shapes too well defined.*

### Tip

*The brushstrokes of different gray tones should be applied quickly and not too carefully. The only goal is to cover the different areas of color with rough brushstrokes. Don't fuss with modeling or details.*

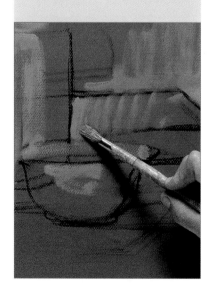

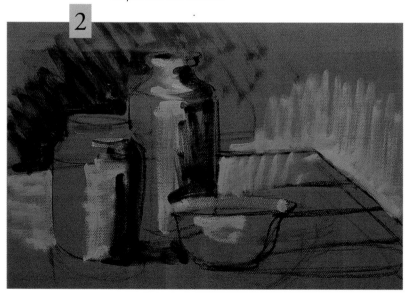

*The main goal is to separate the areas of light from the shadow. To do this, charge the brush with medium gray and apply the medium tones before resolving the areas of greatest contrast. The painting is done with dry brushstrokes that are not too opaque.*

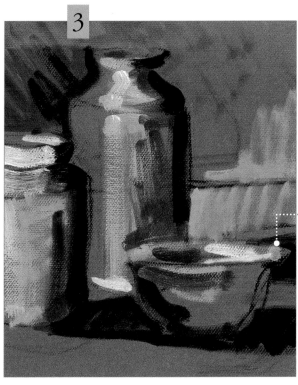

**3**

Don't worry too much about modeling the objects. Instead, concentrate on putting each tone in its place. This way, each element will appear almost without effort.

This step adds the first contrasting lights and darks. Lighten the grays from before and continue the painting process. At this moment, nothing is definite; shadows are placed little by little, defining the form of the light.

**4**

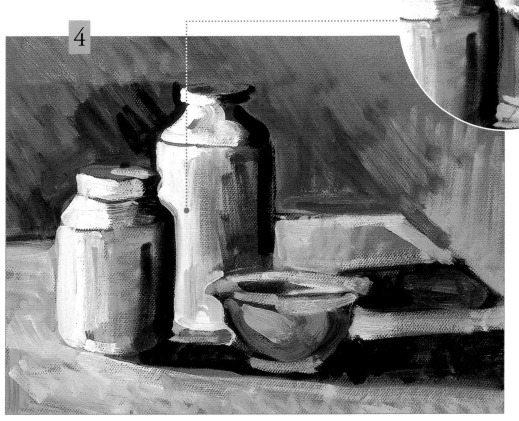

Use a very thick and dense white to cover the most illuminate parts. Make up and down brushstrokes so they will lightly blend with the gray. These white reflections add a greater effect of volume to the objects. The black in the background applied earlier adds contrast to the outline of the bottle and pitcher.

As the illuminated parts of the objects are painted white, the gradations that are needed to explain how the light is distributed on the cylindrical elements appear. Paint the table a medium gray so that the projected shadows will contrast more and be perceived to be darker.

EXERCISES
PRACTICAL

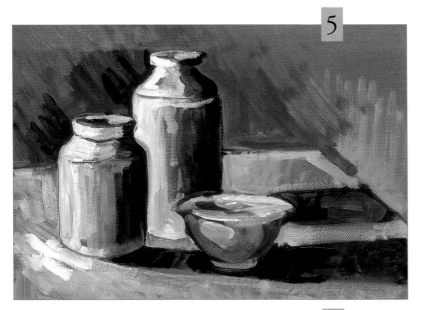

## Tip

*The interaction between the black and white constitutes the minimum graphic expression of light and shadow. It is a good idea to often work with these two basic colors.*

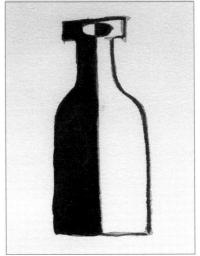

*Continue in the same manner with the shaded areas. Paint the dark half of the object with a dense, barely diluted black, so that the light and dark areas are well differentiated. Distributing the light ensures that the elements of the still life appear to be curved and smooth.*

*Paint the background again with a dark gray to create greater contrast and thus center the attention on the group of objects. The brush marks are left so the painting will look fresh and expressive, and it will contrast with the modeled treatment of the objects.*

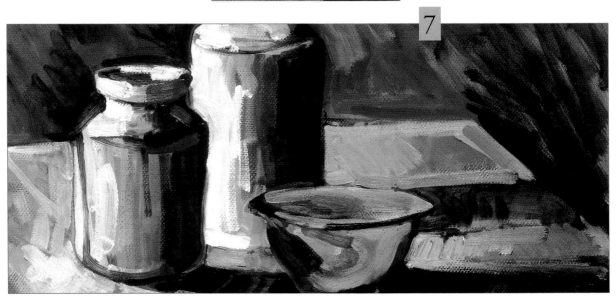

*Now is the moment to illuminate the plane of the table where the objects sit. Since the light comes from the left, the grays seem whiter as they move toward the light source. The layer of paint should be dense and creamy, making it easier to add more emphasis to the brushstrokes.*

34

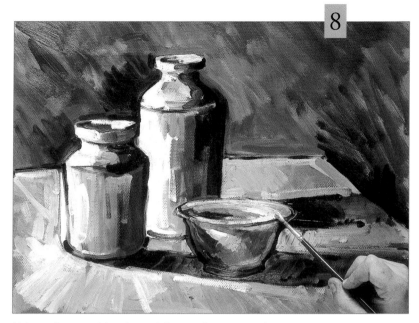

**Tip**

Practice painting plaster models, like those found in art schools, to eliminate the problem of color. Using these figures allow you to create greatly contrasted chiaroscuro studies and experiment with different kinds of lighting.

*Using a fine round brush we define the final shape of the bowl by illuminating its edge. We refine the contrasts to make it stand out enough from the background and the bottle. With the same brush charged with black we add some lines to strengthen the shapes of the objects.*

*If we have distributed the light and shadow carefully, our painting will be quite far along. All that is left is to correct and refine one area or another as needed. At no point in time have we attempted an excessively realistic and detailed representation of the model, but rather a stylized and expressive one, which emphasizes the construction of the painting with the wide brushstrokes.*

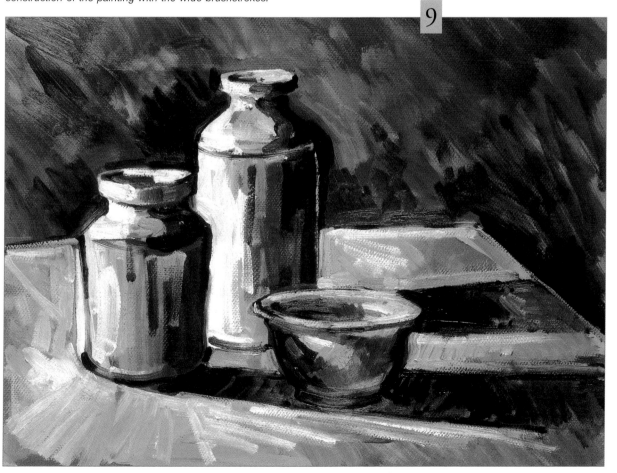

This section shows how art students, still in the formative phase, treat the previous exercise, which was painted by a professional artist. The professional artist and the students made similar studies, which is a good reference for establishing comparisons, analyzing the composition chosen by each student, and the different ways of resolving the light and shade in a monochromatic treatment.

# STUDENT
*Work*

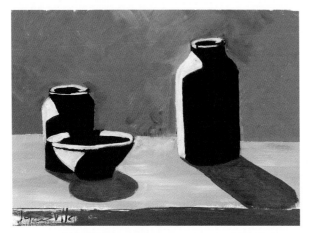

*The first work done by a student is a clearly stylized approach. The intermediate values were left out and the forms were created with block shading–dense black homogenous shadows that cover the object's shading. The projected shadows are also blocks, although of a medium gray. This model was painted by Jordi Gasulla.*

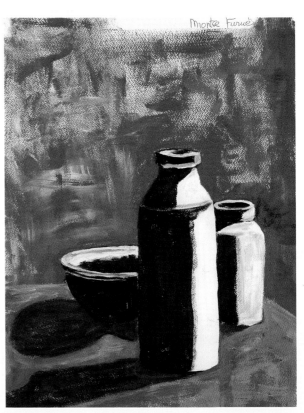

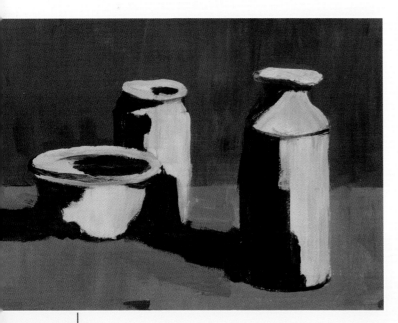

*The exercise by this student presents the same parameters as the previous one, but with some differences that give it a more expressive range. Something textured was painted on the paper, making it easier to use a drier brushstroke, which allowed the grain of the paper to show through (especially in the upper area). This approach adds atmosphere and expressiveness to the background. Work by Montse Furné.*

*Here is another work done with block shadows, using barely four uniform tones. The contrasts between light and shadow are extreme, while the background grays soften the strong interaction between the black and white. The painting was done with a wide brush and thick paint barely diluted with turpentine. This size makes it difficult to maintain the proportions and symmetry of the objects, although this need not be a problem if you are trying to create a simple tonal study in an Expressionist style. Work by Pilar Millán.*

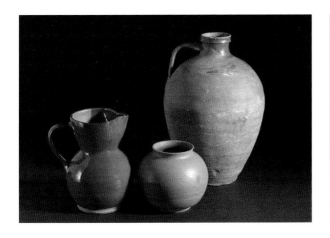

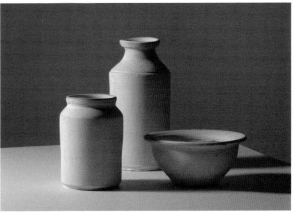

Here the blacks have been reduced to a minimum (only a few lines and some relief or molding on the objects). They do not form part of the shading of the objects, which is done using light tones with little contrast among them. By reducing the size of the objects on the paper, the surrounding space is strengthened. The brushstrokes are wide, the tones subtle and not gradated. The light is so faint that the projected shadows can barely be seen. Painting by Alicia Escobedo.

The light in this painting was re-created by mixing the color gray with white to lighten it and black to darken it. The background was made dark to make the outlines of the objects stand out clearly. Each one of them was constructed with heavy modeled brushstrokes, with chiaroscuro shading in mind. The brushstrokes are directional and attempt to indicate the volume and surface tension of the containers. Work by Emilio Calvo.

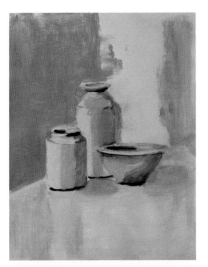

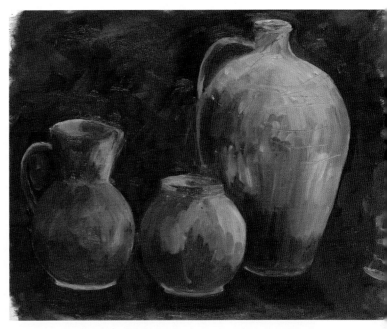

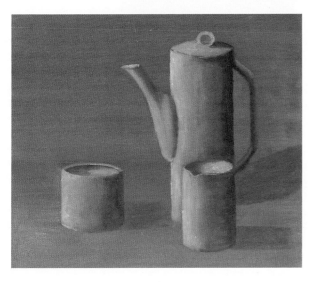

This is perhaps a classic example of modeling. The objects appear to be constructed in a very volumetric manner, because of the careful gradations that emphasize their roundness. The light is the main cause for the effect of roundness. The careful use of a soft-hair brush almost totally eliminates the brush marks and gives the surfaces of the objects a very clean and delicate appearance—a refined smoothness. The contrasts are light, like the tenuous dynamic of the grouping, and there are no jumps or abrupt changes in tone. Work by Enric Gasulla.

STILL LIFE *with* CHIAROSCURO

# STILL LIFE
## *with* CHIAROSCURO

Here is a very simple exercise in drawing and composition for studying chiaroscuro and for experimenting with modeling surfaces with oil paint. The forms of the still life are very simple (all are circular) so the drawing will not be an obstacle to practice the shading that will strongly contrast with the light. This exercise was done in oil by Esther Olivé de Puig.

**1**

The preliminary sketch of the still life is very simple. The outlines of the vegetables are painted with oil over a pencil drawing. The lines are made with very diluted gray colors. Any corrections can be made by rubbing out with a rag and repainting the line.

### Tip

*Make your drawing with a pencil, rather than charcoal. The latter leaves excessive dust, which will muddy the first layers of paint.*

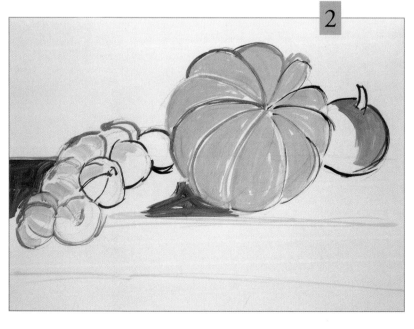

**2**

*After making the sketch of the produce, the first tones are added. The first use of color will be the yellow on the squash. The area is illuminated from the right with orange and the wood with raw sienna. A few brushstrokes of white tinted with ochre are added to the heads of garlic.*

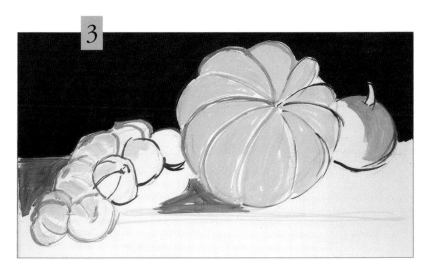

The dark background is painted as a single block of dark color; this will be the darkest tone of the painting. It is done with heavy opaque brushstrokes to create an intense black. The background silhouettes are the vegetables.

Continue with the wood board. The most illuminated area is painted with raw sienna mixed with a little ochre; in the shaded part the tones are denser and darker. To create them, burnt umber was added to the original raw sienna.

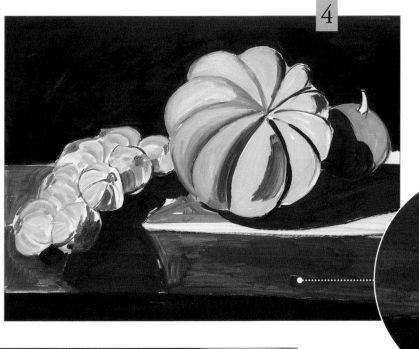

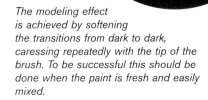

The modeling effect is achieved by softening the transitions from dark to dark, caressing repeatedly with the tip of the brush. To be successful this should be done when the paint is fresh and easily mixed.

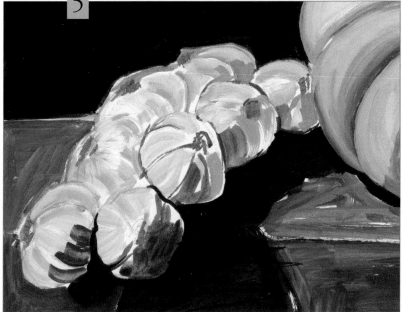

The string of garlic looks white in the photograph. Instead of accepting this, invent colors where there are none. In this case, the artist chose to resolve the volume with brushstrokes of pink and ochre tones.

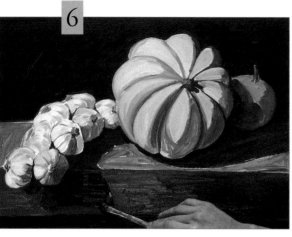

### Tip

Despite what it seems, black paint is rarely used for shading in chiaroscuro. The darkest colors are made by mixing blue, dark green, and a little carmine.

*We make the projected shadows denser and darker with a very dark brown, nearly black, that covers the background. We finish painting the wood surface so there are no spaces left white and the dark shadow is better integrated. The brushstrokes on the wood should be horizontal.*

*The largest squash, is modeled, the illuminated areas are covered with a thick application of lighter yellow paint. The shaded areas are painted with burnt umber.*

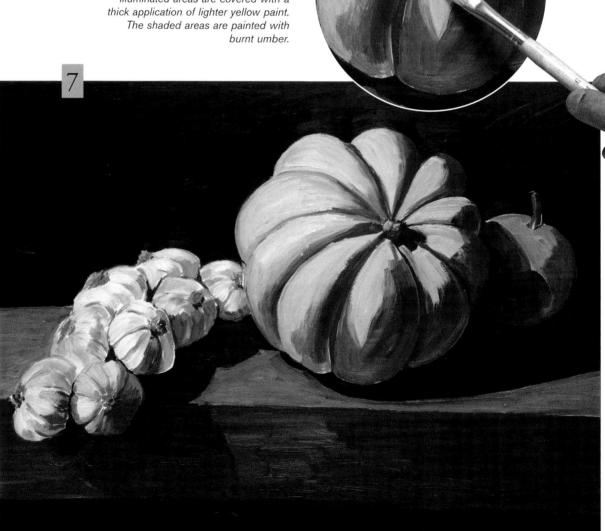

*Only after the chiaroscuro modeling is complete can we darken the projected shadows with a new layer of paint. This will create more contrast with the light areas, indicate the direction of the light, its quality, and the texture of the painted objects.*

# LEARNING *to* MODEL

Modeling begins with creating values, but continues from here to completely blend the tones or colors in the light study. To achieve the correct development of the gradations that describe the volume of the represented surfaces (undulations, folds, smoothness), this technique of blending colors is very important. The movement of the brush, too, should follow the relief of the object to achieve a truer representation, because the forms of the shadows are not developed by gradated tones and colors alone.

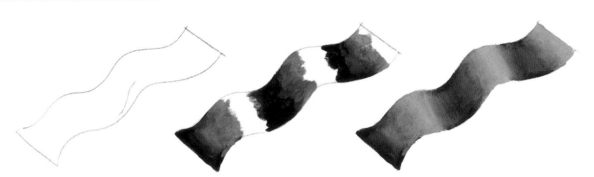

*In the first example the technique of modeling is shown on an undulating surface. First we add different tones of the same color, making them lighter, and keeping in mind that the nearest parts will have a lighter color. Then we brush them to blend the colors with each other.*

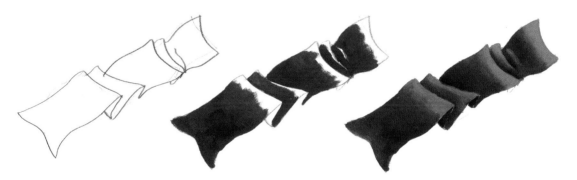

*The folds are modeled with thick, dense paint. In this case the folds should be painted with a lighter color, while the valleys formed in the fabric will be a darker color. Since the relief is much greater, the contrast between the lightest and darkest colors should be as well.*

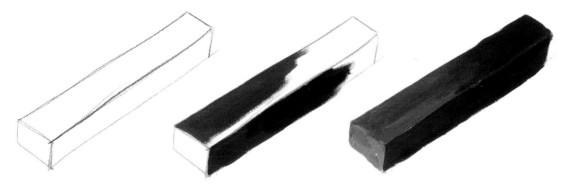

*When faced with an apparently smooth surface the challenges are not any easier. Developing a modeled gradation is very important. In the first place, it is necessary to decide where the light comes from. The colors of the part of the object nearest to it are then lightened progressively; the color is gradated as we move away.*

# PAINTING
## *with* LIGHT

It is common to construct a model by adding the shading; however, this exercise reverses the process. The intention here is to paint the subject by illuminating areas without painting a single shadow. The choice of a dark background is fundamental to achieving success. The areas of shadow will not be touched at all, so that the dark blue background will do the work. This exercise was painted in acrylics by Gabriel Martín.

1

*The background is painted with dark blue acrylics. It is left to dry for an hour and then drawn with a white pencil. There is a total absence of details in this urban scene; the main forms are sketched with very simple geometric shapes.*

### Tip

*When working on a dark colored background don't dilute the color, as it must be very opaque. If necessary you can mix it with a little white paint.*

*The first painting is of the sky, which is covered with a gradation of three blue tones—the darkest above and the lightest below. The light in the sky helps outline the shapes of the buildings and the chimneys. The paint should be creamy and completely cover the background.*

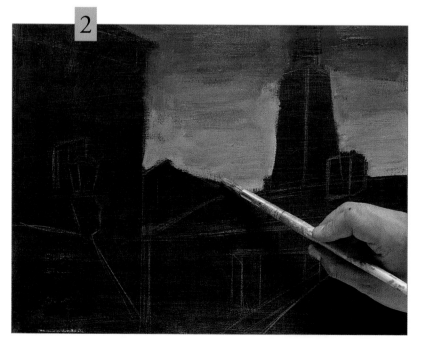

2

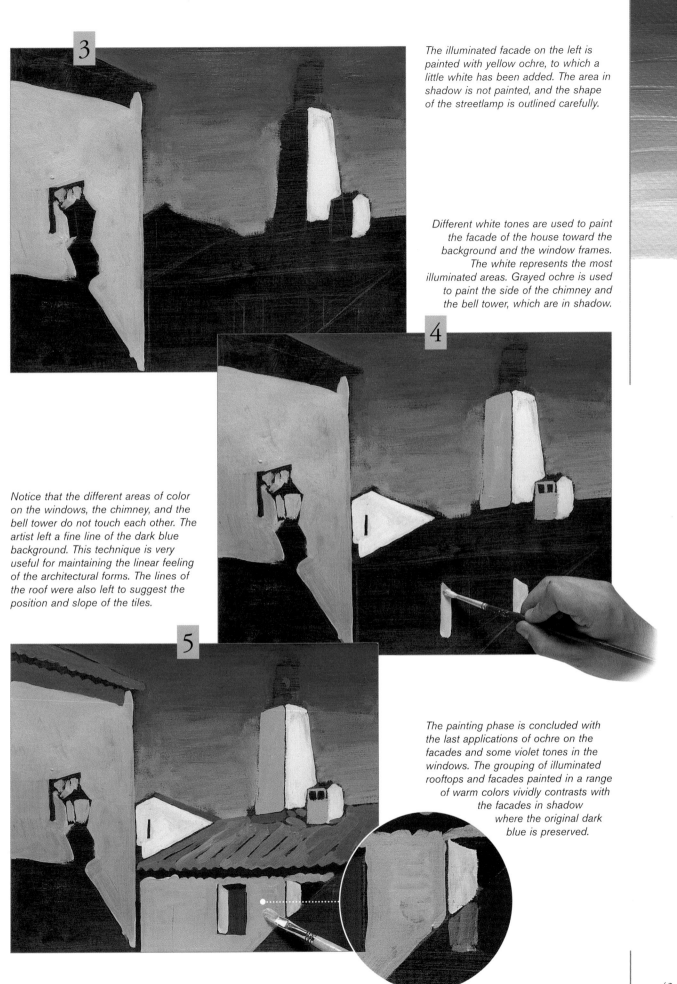

*The illuminated facade on the left is painted with yellow ochre, to which a little white has been added. The area in shadow is not painted, and the shape of the streetlamp is outlined carefully.*

*Different white tones are used to paint the facade of the house toward the background and the window frames. The white represents the most illuminated areas. Grayed ochre is used to paint the side of the chimney and the bell tower, which are in shadow.*

*Notice that the different areas of color on the windows, the chimney, and the bell tower do not touch each other. The artist left a fine line of the dark blue background. This technique is very useful for maintaining the linear feeling of the architectural forms. The lines of the roof were also left to suggest the position and slope of the tiles.*

*The painting phase is concluded with the last applications of ochre on the facades and some violet tones in the windows. The grouping of illuminated rooftops and facades painted in a range of warm colors vividly contrasts with the facades in shadow where the original dark blue is preserved.*

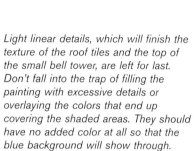

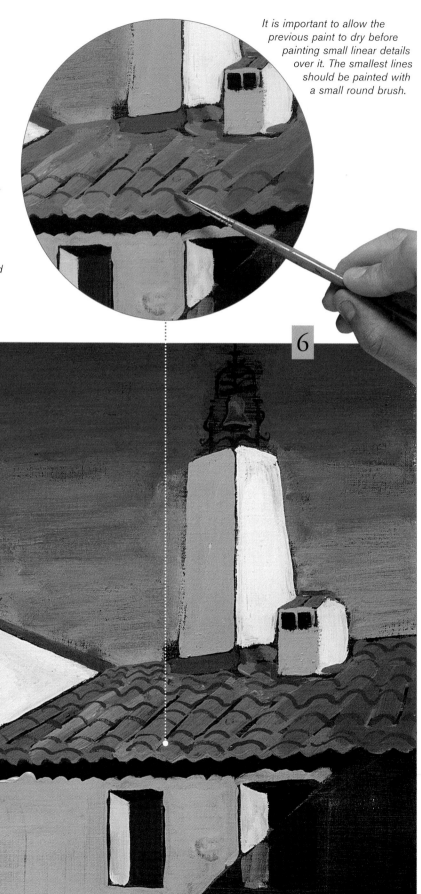

*It is important to allow the previous paint to dry before painting small linear details over it. The smallest lines should be painted with a small round brush.*

*Light linear details, which will finish the texture of the roof tiles and the top of the small bell tower, are left for last. Don't fall into the trap of filling the painting with excessive details or overlaying the colors that end up covering the shaded areas. They should have no added color at all so that the blue background will show through.*

6

# EXERCISES *with* LIGHT

Now let's try to forget about shading completely. Leave aside for a moment the idea that it is necessary to shade to indicate the form and volume of an object. Only in this way can these following short exercises, which work only with light, be understood. When painting with light it is necessary to work on colored backgrounds.

*One way of painting with light is to illuminate the empty spaces around things with color—the environment that surrounds the bodies. This works especially well if the subject is a complex silhouette, like this windmill with openings that let light through. This will help us understand that the representation of an object not only depends on its material and physical state, but also on the air that surrounds it and fills the openings.*

*Working with light facilitates the representation of open trees—trees that are not full but have numerous branches. In these cases it is easier to construct the trees using the contrast of the light of the sky instead of doing it with brushed lines of brown on a white support.*

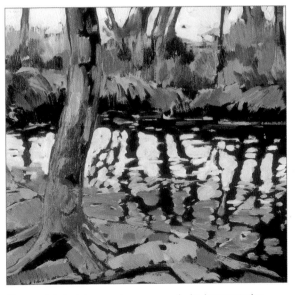

*Try painting using this lighting technique. On a dark background it is easier to paint the light in the picture, no matter how complex and detailed the forms may be. It is best to start working with light and whitened colors.*

*If you wish to later create a more colorist interpretation of the illuminated areas, it is easy to overlay bright colors on the light spaces. The areas of shadow are not touched at all.*

45

# *A* BACKLIT
# LANDSCAPE

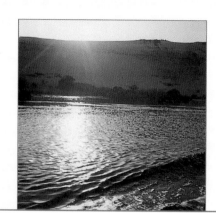

When you depict a landscape with the sun near the horizon, directly in front, a silhouette is created. This blinding effect keeps you from easily distinguishing the different grounds of the landscape. To represent this particular luminous convergence in a painting, you need to consider the different factors that are presented in the following exercise, painted in oil by Gabriel Martín.

*The background of the support is painted with sienna brown. The subject is drawn with a stick of graphite. It is enough to indicate the edge of the sky and the bank of the river, any more details will be useless, since they will be covered by the first brushstrokes.*

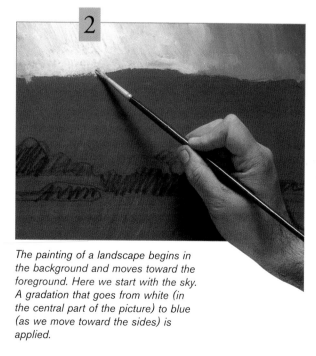

*The painting of a landscape begins in the background and moves toward the foreground. Here we start with the sky. A gradation that goes from white (in the central part of the picture) to blue (as we move toward the sides) is applied.*

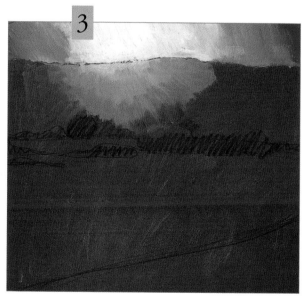

*After resolving the sky, the outline of the mountains is addressed with tonal variations of ochre and burnt umber. The lightest ochre is placed next to the white of the sky; it is then darkened to create a tonal scale in a circular arrangement.*

To finish painting the mountains the gray color is darkened as it moves farther from the light source. The treatment of the color is more homogenous. Medium-dark browns are used because the silhouette tends to darken the grounds of a landscape.

All the brushstrokes should converge at a single point in the sky. They will be more intense near the source of light and weaker, that is to say, mixed with the underlying color as they move away. To resolve this part of the painting, the filbert is the most useful brush.

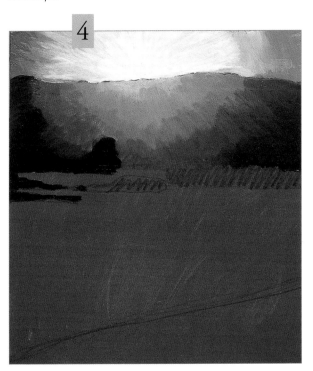

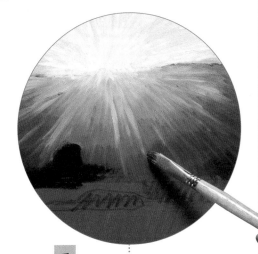

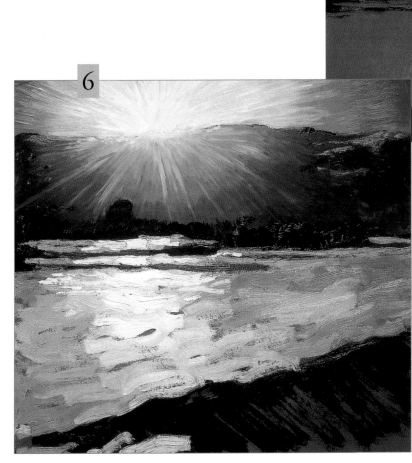

To create the dazzling sunlight that occurs as it dips behind the hill, and making use of the still-fresh layer of paint, more or less concentric, diagonal brushstrokes are drawn with a little bit of white. The vegetation is painted with a dark silhouette, mixing brown and violet. This same color is used to darken the foreground.

The water is sketched with a whitish blue that tends toward violet. Opposite of what happens with the landscape that becomes darker, the water is illuminated when backlit. Right where the sun is at a vertical angle the water is whitest and most resplendent. Moving away from this point, the color becomes bluer.

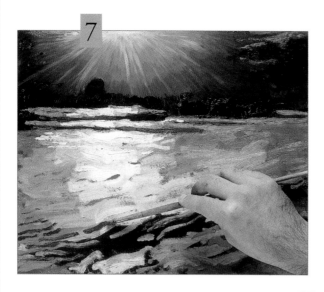

The shadows of the waves are painted on the gradated colors that depict the water. Short, successive, and irregular brushstrokes of lightly diluted violet are applied with a medium round brush to illustrate the agitated surface of the river.

While the size and direction of the brushstrokes in the foreground play an important part in illustrating the waves on the surface of the water, a few lines scratched with the brush handle do the same in the background.

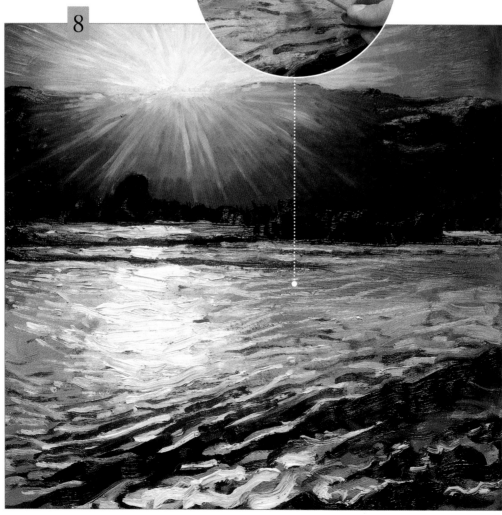

New and stronger white brushstrokes cover the surface of the water, although this time they are thinner and concentrated around the main reflection of light. In the lower part of the painting, near the violet shadow, the waves become bluer. Don't make the mistake of covering the clearly diagonal shadow too much as this line strongly animates the composition.

# GLOSSARY *of* LIGHTS

In the previous exercise you discovered how to represent the rays of the sun in a backlit painting. This one looks at the different ways of representing light with oils when painting the light source itself. Each interpretation is different and describes a particular kind of light. It is a good idea to study all the possibilities and learn to vary the technique according to the effect caused by the light, whether it is natural or artificial.

*A.* The simplest manner of painting the expansion of light is based on a white center with circular brushstrokes around it, representing a tonal scale of yellows and oranges. The tones are blended with a dry brush while the paint is still wet.

**A**

*B.* To represent the rays, paint as described in the previous example, but use a craft knife to make lines in the fresh paint, tracing radial lines that represent rays of light.

**B**

**C**

*C.* This version is much more loose and gestural. Superimposed irregular circles are painted with yellow, tighter in the center and more free and loose on the outside. The brushstrokes are made very quickly. A thick stroke of white is applied in the center of the yellow.

**D**

*D.* Starting from a light yellow center dabs of different colors representing the expansive effect of light are added. Overlaying and combining brushstrokes of different colors does the rest. This treatment, very similar to Pointillism and Futurism, creates a dynamic effect.

**E**

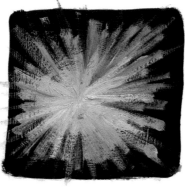

*E.* The glare of car headlights is painted on a still-wet black background. This light is blinding—it consists of light yellow brushstrokes in a star configuration that should be painted from the center to the outside, never the other way around.

**F**

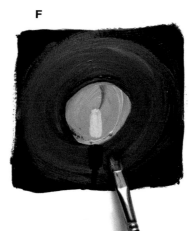

*F.* This example suggests the light of a low-intensity streetlamp or light mitigated by the effect of fog. It begins with a yellowish circle within another that looks like a gray aura. Represent the lamp with a white brushstroke placed in the center.

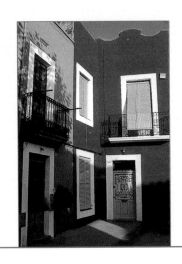

# *Shading with* CONTRASTING COMPLEMENTS

The following scene is interpreted within contrasting complementary colors. This means that if the facades are yellow and red, the shadows should be made with violet and green. Working this way, the impact of color is strong and the contrast between colors that are so far from each other on the color wheel emphasizes their value. Esther Olivé de Puig painted this exercise with acrylics on white paper to achieve bright and luminous colors.

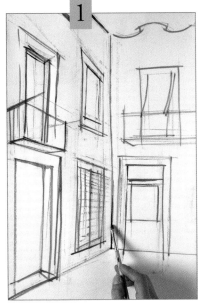

*The initial sketch is made with graphite pencil. The drawing is retraced with a somewhat diluted black, without allowing the paint to drip. To keep it from running on the surface of the painting the brush is lightly pressed on the edge of a small container before application.*

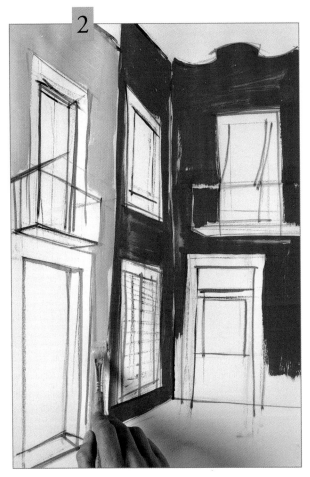

*Begin with the largest areas of color; in this case the two facades with their characteristic colors of red and yellow. The colors are bright from the start, right out of the tube with no mixing or additions of other colors. The doors and windows are left unpainted.*

### Tip

*When acrylic paints are used on paper they dry very quickly, so don't worry about applying laborious gradations or modeling effects. The best way to apply the color is to use clean, unmixed paint.*

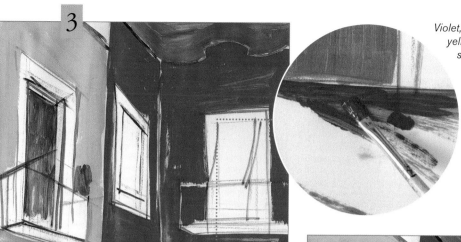

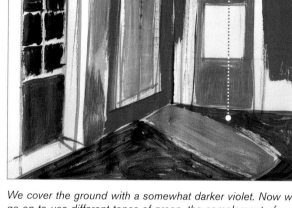

We cover the ground with a somewhat darker violet. Now we go on to use different tones of green, the complement of red. It is a good idea to point out again that the greens and violets should only be present in shaded areas, never in a place that receives direct light from the sun.

*Violet, the complementary color of yellow, now appears on the scene. The doors and widows are painted, adding white to keep the color from getting very dark. The sky is painted with a more bluish violet.*

*We wait for the layers of paint to dry and we darken the ground with new coats of violet. Then we enhance the red on the facade by painting another layer of this color on the previous one. Using diluted red and blue we cover the white of the windows that still need to be painted.*

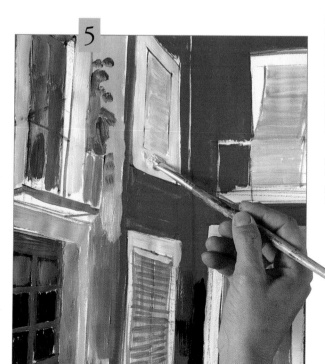

*Having arrived at this point, where we have finished covering the white on the paper, the applications of color will be denser and thicker. The frames of the windows are now painted with light yellow and a little ochre. We begin paying closer attention to the details and brushstrokes that are becoming smaller and more precise.*

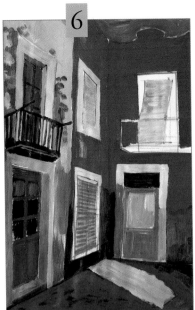

6

The ground requires a last minute correction; the green area is covered with yellow tones because it is illuminated. The violet that surrounds the area is lightened to create a more lively complementary contrast.

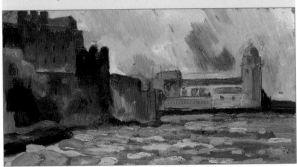

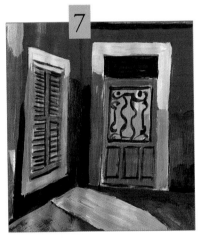

7

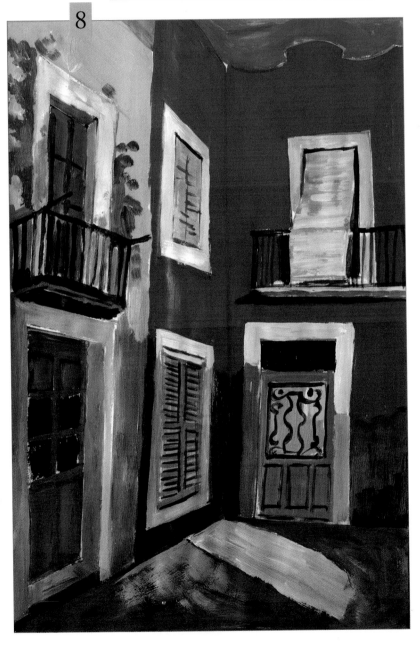

8

The color treatment is finished, and a fine round brush is used to make some linear additions to define the wrought iron of the doors and verandas of the balconies. This, in addition to some linear work on the windows, helps define their shapes.

With the work finished, observe how the violet areas constantly interact with the yellow ones (on the facade, the ground, the blinds, the doors) while where the red is seen, this color also contrasts with its complement, green (in the vegetation in the window, the corner, and the facade at the right). Painting light and shadows with saturated complementary colors gives the painting a very lively and stimulating effect.

# EXPERIMENTING *with* TECHNIQUES *of* CONTRAST

The contrast between complementary colors allows the artist to alter the intensity, the amount of saturation, or the definitive tones of the colors, to achieve many combinations. Exercises like these, which translate the light and shadows of a model into bright colors, alter the combinations until the desired chromatic results are achieved. Here are several possibilities of color offered by a single model.

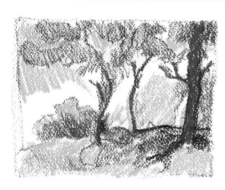

This model contrasts two complementary colors, violet and yellow. The latter is chosen to represent the light. Perhaps there is too great a tonal difference between the two colors.

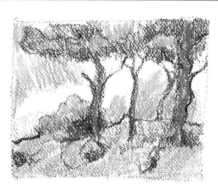

Here's what happens when the violet is replaced by a blue that is more tenuous and lighter. The contrast between the light and shadows is more harmonious.

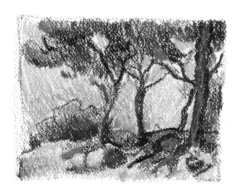

If the blue contributes to attenuating the contrast, let's see what happens if we combine violet and blue in the areas of shadow. It helps the violet harmonize better with the yellow, to which greater warmth has been added with a few strokes of orange.

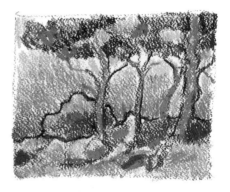

This progression of colors concludes by shifting the violets toward the blues, and the yellows toward more orange colors. In this way, another complementary contrast between orange and blue is achieved.

Although the contrast between red and blue is not complementary, it also is very effective, although the use of yellow is necessary for gradating the red.

For a fuller and more artistically attractive contrast, green should appear in the shadows instead of blue. The effect of complementary colors adds more energy to the work of art.

*Interior with*
LAMPLIGHT

# INTERIOR *with* LAMPLIGHT

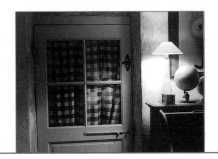

The following step-by-step exercise follows the development of an interior illuminated by lamplight. Including the light source in the composition is very exciting. Since very little color is used, it is very easy to follow the process. You will, however, have to pay special attention to the mixing of the colors, the color tendencies of the areas of light, and the linear separation between the brushstrokes. The end of the lesson explains why. Mercedes Gaspar painted this exercise in oils.

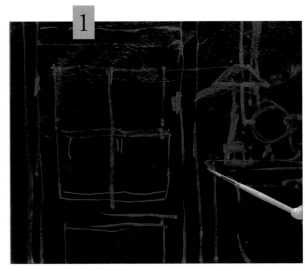

Sketch the shapes in the interior on a support covered with a dark color. Blue paint is used directly for this. The drawing is shaky and imprecise. This corner was chosen to avoid any problems with perspective.

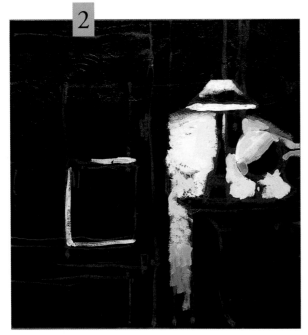

The initial sketch requires little precision, although it should lay out the most important forms so the colors can occupy their approximate places. The lamp is the first objective, and it is resolved with a yellowish white and two orange tones. All this is done with thick opaque paint.

### Tip

The point of this exercise is to achieve a wide range of tones that can be applied as more or less homogenous brushstrokes. If you only work with differentiated strokes, the contrast between the colors will do the rest, reflecting the incidence of light on each surface.

*The shaded area of the doorframe is approached with different variations of violet. To paint the window, prepare a new mixture with a sienna brown and a bit of that violet. The brushstrokes should go up and down to suggest the characteristic grain of the wood.*

*Here is how the window was resolved. The artist used different brown tones, adding carmine, ochre, white, and light violet to the same mixture. This makes it possible to obtain several variations based on a single color.*

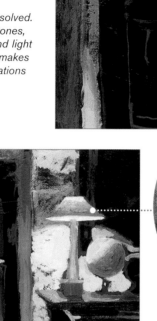

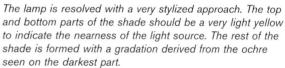

*The lamp is resolved with a very stylized approach. The top and bottom parts of the shade should be a very light yellow to indicate the nearness of the light source. The rest of the shade is formed with a gradation derived from the ochre seen on the darkest part.*

*It is time to paint the door. The chosen color is violet. In some areas this color is gradated with a whitened sienna, and in others, it looks somewhat darker thanks to the intervention of cobalt blue in the mixture. The desk is finished with very somber browns, except for the top, which is strongly lit by the lamp.*

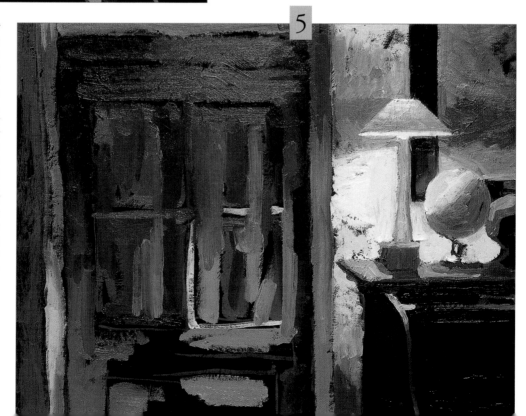

Simply lightening the door with new brushstrokes makes the painting more luminous. Nearly covering the dark background that interfered with the appreciation of the colors makes this possible. The direction of the brushstrokes in each area add vigor and some movement to a subject that is traditionally static.

**Tip**

The lines that define the cracks and outlines of the doors, the furniture, and the objects are not painted. They were made by reserving a narrow line where the original background shows through.

The differences between each area are established with tones that are completely different and that do not blend with each other. The final choice of colors is adjusted. In lighted areas the yellow tones dominate, while in the shadows the predominant color is a very light and tenuous violet. Without a doubt, this approach uses the contrast of complementary colors without the level of saturation we saw in the previous exercise.

Dabs of green are used to create the polka dots on the curtains. The green should never be pure, but lightened or darkened depending on the amount of light each area receives.

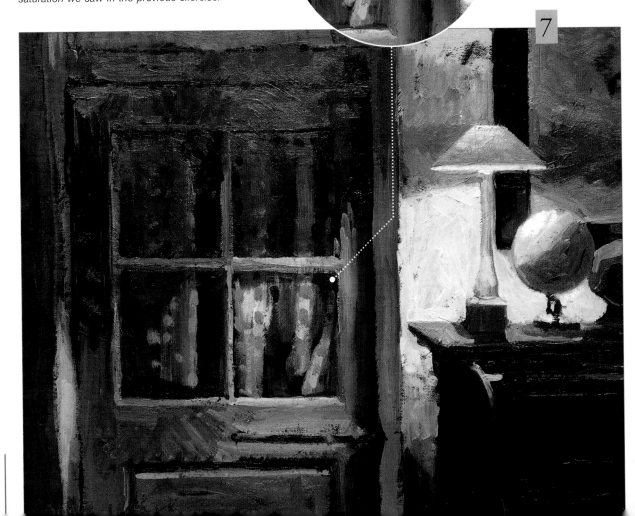

# *Some* ARTISTIC TECHNIQUES *for This* EXERCISE

The artist uses several effects or artistic solutions to resolve specific areas of the paintings. This section analyzes each in isolation, which should allow you to better concentrate on the use and application of color.

*The transition from light to dark is made gradually using very light yellows near the lamp and orange tones as the light loses intensity.*

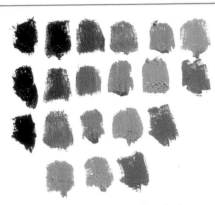

*The green brushstrokes that depict the polka dots on the curtain are done with greens of different intensities.*

*The table was finished with dark browns; the contrast between one value and another is minimal. The light highlights the edges of the furniture piece. They are painted with different ochre tones.*

*A narrow space is left between brushstrokes, allowing the background to show through. These reserves allow the artist to represent the lines that delineate and better explain the shape of the door.*

*The illuminated background creates the shape of the desk. Contrast is one of the basic tools of the artist for representing shadows without the need for lines.*

*Working with slightly diluted paint and a dry brush creates a textural effect, which does not completely cover the background. The relationship between the background and the color on it creates a surface with granulated paint that confers an interesting texture.*

*Learn to construct spheres with gradations. If you work with thick paint you will be able to lighten and blend the colors with each other.*

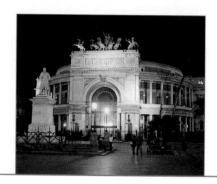

# A Nocturnal SCENE

# LIGHT *in a* NOCTURNAL SCENE

Night is not the negative result of the removal of light, but the replacement of daylight with artificial light, creating shadows with greater contrast and phantasmagoric effects. In this exercise painted in acrylics by Gabriel Martín, a majestic building and a plaza are illuminated by several light sources, which are translated into beautiful saturated colors. Special emphasis will be placed on studying the propagation of light in the form of gradations and on the strong contrasts that show the light on the facade and group of sculptures in the foreground.

The background of the support is painted an intense blue in a gradation. The lightest blue is located in the middle of the support. Dark backgrounds are very useful for painting works where light is of little importance.

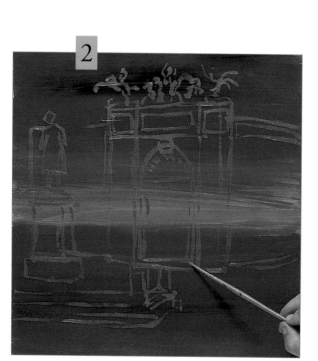

The initial sketch is not made with a pencil. The architecture is framed with a small round brush and pure cadmium red. The lines do not have to be accurate, and there's no need to worry about deforming the architecture. On the contrary, a little visual alteration gives the painting greater expressiveness.

### Tip

The secret of painting night scenes is in the contrast. The colors used on the facade should be very saturated, bright, light, and contrast strongly with the background color.

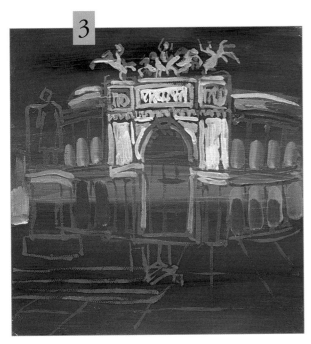

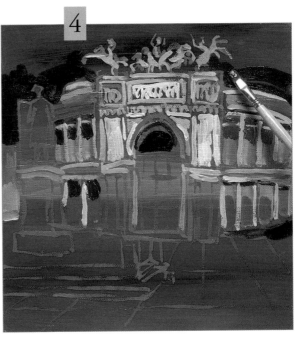

The illuminated facade is constructed with bright colors. Yellows, oranges, and reds predominate, except for the bronze sculptures, which are resolved with a very bright green. Don't cover the initial red lines completely; it is better to integrate them with the colors that define the light.

The sky is partially darkened with a black tone. The black is concentrated around the outline of the top of the building; its main function is to increase the contrast between the total absence of light and the illuminated architecture. Brushstrokes of black paint are applied in the spaces between the bronze statues.

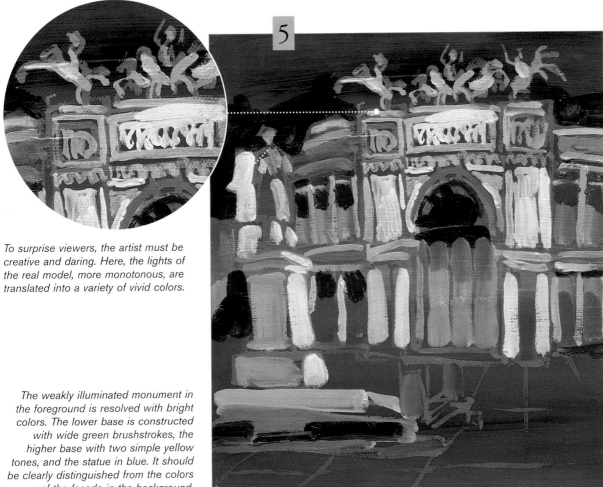

To surprise viewers, the artist must be creative and daring. Here, the lights of the real model, more monotonous, are translated into a variety of vivid colors.

The weakly illuminated monument in the foreground is resolved with bright colors. The lower base is constructed with wide green brushstrokes, the higher base with two simple yellow tones, and the statue in blue. It should be clearly distinguished from the colors of the facade in the background.

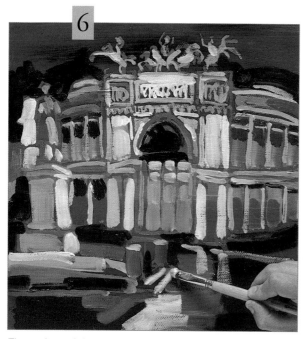

6

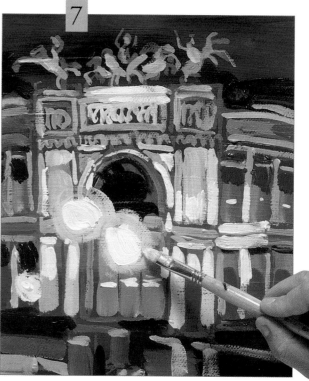

7

The surface of the plaza is darkened with the same black used for the sky. When the color is dry, a large red area is applied in the center. The most intense reflections on the pavement are highlighted with yellow brushstrokes. Color is applied in a very stylized manner without need for detail.

Now it is time to paint the light of the streetlamps. Because the light is so intense, the shape of the streetlamp disappears completely and only its light can be seen. It is depicted with a central white circle and gradated with a ring of mixed yellow and white.

8

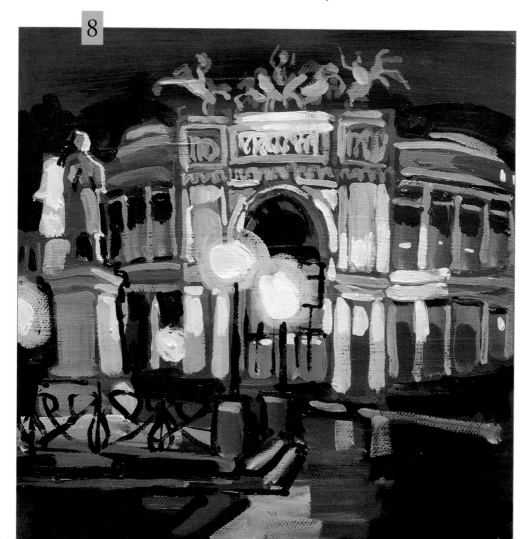

The exercise concludes with smaller brushstrokes that complete the earlier ones. The focus is on the reflections, windows, and architectural details. Carmine, green, and dark blue are mixed to make the black for the iron railing that surrounds the monument.

# PAINTING *a* LIGHT HALO

The ability to paint a halo of light has always attracted the admiration of painters and art enthusiasts; nevertheless, it is something that is quite easy to master. The final result is a light source with a circular halo that ranges from greater to lesser intensity from the center to the outside. This exercise analyzes step-by-step how to successfully represent the effect of the dispersion of light.

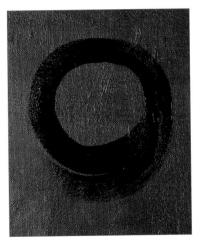

*The zone is created with a circle of violet paint mixed with dark brown.*

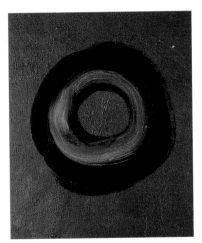

*A new circle is added inside the previous one, this time using a violet mixed with white.*

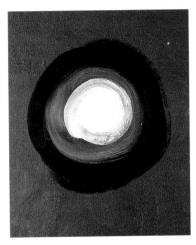

*To complete the tonal scale the center space is filled with a new circle of white paint.*

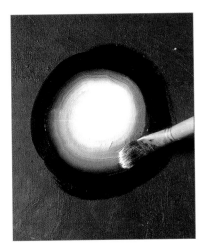

*Circular motions with the tip of the brush are used to drag and blend the white with the outside colors.*

*The result is a gradation with very smooth transitions that begin with white, the brightest area, and progressively pass to violet, which represents the darkness.*

*A bit of yellowish white around the center makes the light source feel warmer.*

# FILTERED LIGHT

FILTERED LIGHT

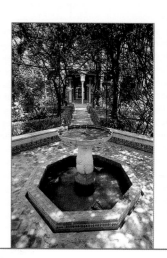

The light we see when sunlight filters through the trees creating patches on the ground is one of the most effective techniques of rendering light, and one that is reminiscent of Impressionist paintings. Despite its complexity, filtered light can be easily re-created with watercolors by reserving the color of the paper. This work by Mercedes Gaspar demonstrates how it is done.

After the garden is drawn, a violet wash is added to the arches in the background, which are blended with additions of green and raw sienna in the mass of vegetation in the upper area.

The work begins with an outline or a carefully created pencil sketch with especially good details on the fountain. This is the only way to apply each wash in its exact place.

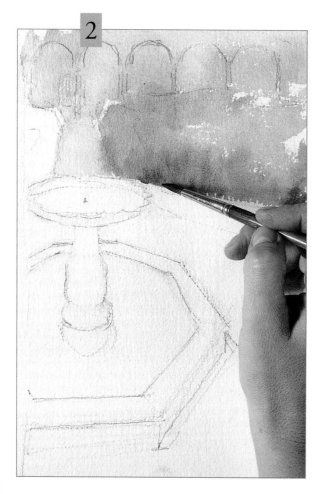

### Tip

Before applying any color it is a good idea to retouch the shape of the fountain and draw the spout of water with white wax. This creates a reserve on the paper to ensure that these lines will stay white despite later washes of paint.

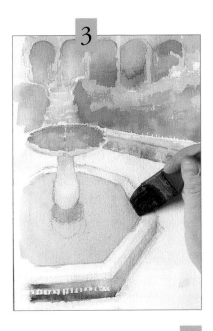

3

The water in the fountain and the tiles on the benches are painted using a wash of burnt umber, which is immediately touched with small dabs of blue, but using only the tip of the brush. A wide brush is used to apply an ochre-sienna wash on the arches in the background and another to the pool.

*After the background has completely dried the trunks of the trees are painted. The ground is painted with a mixture of violet and sienna, leaving small areas of white on the paper to simulate splashes of light filtering through the trees. The white reserves are made smaller as they get farther away.*

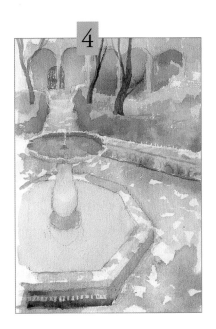

4

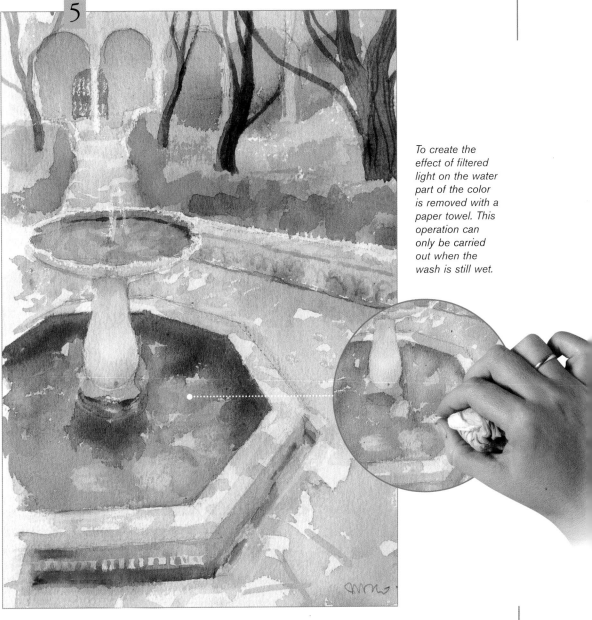

5

To create the effect of filtered light on the water part of the color is removed with a paper towel. This operation can only be carried out when the wash is still wet.

*To finish, the water in the pool is painted with a wash of sienna mixed with ochre. The shadows projected by the column of the fountain and the bench that retains the water are resolved by adding raw umber and a little violet to the mixture. Remember that this is the last step; each part of the picture is painted when the adjacent color has dried.*

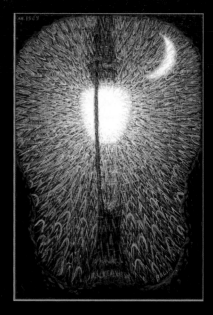

Giacomo Balla,
*The Streetlamp*,
1909.
Museum of
Modern Art
New York

# THE LIGHT OF
# THE FUTURISTS

Above: Giacomo Balla
Below: Carlo Carrà

Futurism was a literary movement, mainly Italian, but it had important expressions in painting. A group of Italian poets led by Marinetti believed that art should show a new dynamism, adapt to progress, and look toward the future, all ideas which gave the movement its name. The Futurist painters showed great interest in capturing the sensation of movement, representing speed, and capturing the effect of electric light in a fleeting and energetic way. "We declare that the splendor of the world has been enriched by a new beauty: the beauty of speed. A race car is more beautiful than the Victory of Samothrace."

This interest in representing the effect of light was a common denominator in the paintings of Giacomo Balla and Carlo Carrà. Balla created an impression of light and speed in his work *The Streetlamp* (1909). He was inspired by one of the first lamps with electric light in Rome, where he lived. He deliberately juxtaposes the rays of projected light violently emitted in the form of multicolored darts, creating a luminous, vibrant aura. As he wrote, "We want the impact of all the angled corners, the dynamic arabesque; the oblique lines that fall on the viewer's senses like

arrows raining from the sky." Until that moment, few artists had dared to break the rays of light into such small pieces.

Carlo Carrà, in his work *Leaving the Theater* (1910-1911), also gave priority to a scene in which electric light is the protagonist. Carrà used the divisionist technique, which depicts the vibrant energy by building up dabs of color. The radial beams of electric light were a constant theme of the Futurists, who said that "for us, the pain of man is as interesting as that of an electric lightbulb that suffers, cries, and screams with the shrillest expression of color." The artist presents a metropolitan nocturnal bathed in the light of streetlamps, where the human figures look like specters immersed in a multicolored atmosphere. Carrà wrote about it: "Everything moves, everyone runs, it all takes place with such speed. A figure is never stable before us, but appears and disappears incessantly. Because of the persistence of the image in the retina, things in movement multiply, deform, and are followed by vibrations in the space through which they run…Man and his environment are in a constant dynamic relationship, in which 'movement' and light destroy the maternity of the bodies."

Carlo Carrà, *Leaving the Theater*, 1910–11. Oil on canvas, Estorick Foundation, London, Great Britain

Giacomo Balla, *The Workingman's Day,* 1904. Oil on cardboard. Private collection.